AURA IMAGING PHOTOGRAPHY

Johannes Fisslinger

AURA IMAGING PHOTOGRAPHY
Seeing the Colors of your Aura

Introduction to the Theory
and Practice of Aura Imaging Photography

Translation from German by
Daniela Rommel-Hathaway

SUM

Original title : Aura Visionen
Einführung und Praxis der Aura Photographie
ISBN 3-9802829-02
Gruber Verlag
Kohlstatt 3
D 82205 Gilching (Germany)

Technical support by
Guy Coggins, high voltage technology expert

© Sum Press 1995
ISBN 0-9629352-3-9
SUM Press
P.O. Box 2431
Fairfield, IA 52556
Tél. 515 469 3748
Fax 515 469 5906

To order this book:
Send $12 + $1 for postage
to Sum Press
P.O. Box 2431
Fairfield, IA 52556

Contents

Acknowledgments

I like to express my love and gratitude to all the people, who helped me publish this book.

My particular thanks goes to Martina, my german publisher and to Guy Coggins for his technical support.

My appreciations go especially to Dr. Balaji Tambe, Dr. Fred Bell and all other inspirational teachers, who supported me in my growth.

Foreword

Creativity, normally associated with the arts, and science, normally associated with research, can and must work quite well together bringing to birth ever newer technologic frontiers. These frontiers springing forth from the previous boundaries create recombinate technologies wich seem so natural and obvious with insight. Riding on the crest of new technologic frontiers is generally exciting and stimulating, a little bit like surfing in the twilight just before dawn, inherently risky but drawing on and advancing the previously under utilized synergies of past inventiveness. Biofeedback Imaging Technology is one such emerging newly recombinate technologies utilizing previous relatively standard pieces of techno-wizardry in previously unheard of combinations. This is creation in the making.

The ability to graphically depict normally unseen phenomena via transformation functions operating with the mathematical precision of the physical sciences can be likened to discovering the light switch in a room heretofor ignored by all but a handful of specialists. The gift of light in the darkness creates the opportunity for this group to accelerate the exploration process and at the same time permit access, appreciation, and utilization of these vistas by the non-specialist. The technology has a few more invasive precursors, Roentgenology, Radiology, and less so invasive NMR and Ultrasonic Imaging technologies. As with these, the utility range and cross impact during the inception period can only be a matter of rough

conjecture. However, as a new tool, these conjectures can only be said to be apriori underestimates. Welcome to a new techno-frontier. This book can be said to be a form of welcoming mat to inquisitive newcomers and likewise specialists on the lookout for new tools and methodologies to augment and supplement the current implementations.

Dr. John Start
Former Clinical Radiology Director,
Palmer College of Chiroparctic-West

I. New Technology

My two friends and I walk into the high voltage detection laboratory. The smell of ozone lingers in the air. The lab is filled with electronic equipment racks of parts. A huge 6 foot tall Tesla coil glows as thousands of sparks crackle toward a plastic covered metal disk over 3 feet away. There are bookcases full of titles like *High Voltage Corona, the Engineering Handbook*. There are tables laden with circuit boards, various colored wires and strange looking parts. Technicians are busily soldering parts together, while over in one corner we see a woman with biofeedback probes pasted to her forehead like two round bandages with wires connected to a computer screen. The screen is alive with colors, and they change wildly as she plays a simple game of computer tic tac tow. In front of us is an ordinary chair placed in front of a movie screen with a video projector focused on the screen at the other side of the room. One of the technicians in a white lab coat asks me if I would like to see my aura, and motions me to the chair. I sit down, place my hands on the two sensor probes looking like something out of a science fiction movie: two polished white pedestals with many small metal strips formed to exactly fit my hand. I then look into an ordinary mirror at the other end of the room, and see my reflection with beautiful bands of the brilliant color yellow. The computer's loud speaker says in a mechanical-like voice, "Yellow, very intellectual", and then it becomes quiet. The vibrant shades seem to magically dance around my head.

Someone mentions the name of an individual I have an emotional connection with. The colors suddenly

explode chaotically, at the mere mention of that name. My friends stand in front of me, one on either side, and we start talking. The color changes to green when talking to my friend, Guy Coggins, the inventor, then changes to yellow when my other friend starts laughing. I feel as if my emotions are being shown in Technicolor on a movie screen, although the color changes lag a bit behind my actual emotional reactions. The faster I switch my attention from one individual to the other, the faster the colors change. Soon I feel comfortable, and I'm having fun being with my friends. A new level of interpersonal genuineness is emerging in this exciting laboratory. I see the color surrounding me reflecting the color of the aura photograph of the person I'm talking to. We have the same colors! I'm changing to the color of the person I'm talking to!

I begin to fantasizing keeping my eyes open I can see the colors following each change of thought. If I imagine myself in a beautiful garden the colors change to soft blues and greens. When I think of the warmth of the sun the color brightens to yellow.

My friend asks if I want to experience a deep meditation and says if I deeply relax, the color on the screen could change to a deep, indigo blue. The colors at the moment are aquamarine. I relax a little more and soon I'm floating in the thoughtless state of alpha and my inner chatter subsides. A oneness, a dream-like quality, overtakes me and I feel extremely relaxed. When I stand up I feel carefree, light on my feet, and peaceful. I feel as though I'm bathed in blue light. I leave the screen behind me, and I can feel the blue light surrounding me.

The inventor, Guy Coggins, then softly explains to us how it all works. He walks over to the movie screen,

lifts the screen to reveal a huge circuit board with hundreds of small round probes about 1/2 inch in diameter. He explains how each probe in the grid represents the same area on the video monitor. He places his hand on one of the plastic pedestals explaining how each metal contact of the hand plate represents an acupuncture point, with each individual point corresponding to a different part of the body. This information is used to form part of the image, and in order to make it move, we add radio imagining. The radio energy is transmitted to my hand by the same metal contacts used to differentiate the acupuncture points. The radio frequency goes through my body, he says, causing my body to become the transmitting antenna like that of a portable telephone. There are waves of energy radiating from my body in all directions. Some of the radio waves are picked up by the grid imaging receiving antenna.

Mr. Coggins then waves his hand in front of the screen. We can see the outline of his hand on the monitor. Guy explains we are seeing the shadow of the aura like an x-ray. He asks two people to sit in front of the sensor board, and at the same time, he explains that if two people feel good about each other, the electrical resistance on the side of the body closest to the admired person will lower, and this effects the flow of energy. We can plainly see the video field joining the two with a beam of color. He goes on to say if people don't like each other, then the fields will repel. Like attracts like, he says. If one is dominate over the other, you can see the energy field of the stronger one reaching out and sometimes encircling the receptive one.

The Aura Imaging System of the future will be able to listen to us as well as talk, and we will be able to have a conversation with the aura imaging device. The computerized biofeedback unit could be an aid to therapy as it could ask us questions such as "how to you feel about your mother? How do you feel about your father?" And depending on the biofeedback response, the computer could start asking more specific questions, then would branch down to reveal that point in life where one made some of those decisions that control our defense mechanisms, therebuy, making those hidden thoughts rise to consciousness. We can use this technology to change ourselves, to bridge the gap between the unconscious and the rational mind, to make that leap from where we are now to the next level. This may sound farfetched but if we look at the events of the recent past we can see that the technology is already here. It will take some time for us to accept these concepts, although they are not new. Biofeedback was first used by Ron Hubbard in the fifites. Mr. Hubbard founded the Church of Scientology and worked out a method called "clearing" to control the unconscious mind, which he called the reactive mind. Although this method was effective, it was rejected by the therapeutic and psychiatric community because Scientology was seen as a cult. The rejection of his biofeedback ideas was a sad loss for humanity, but now we are taking this idea to new levels with greatly improved biofeedback imaging information and computer processing. We intend to make this technology available to the general public at a reasonable price so average people can learn to be more emotionally genuine.

It All Started When ...

... I had my aura photo taken out of curiosity. I was at a holistic healing exposition and had just come from a workshop on relaxation when I came to the display on Aura Imaging Photography. It was interesting I moved closer, and a young woman asked me if I wanted to see the heat energy around my hand. Just place your hand on the heat sensitive plastic", she said. When I did, she took one look said, "wow! you are very relaxed, and look at the intensity of these colors, you have healing energy". I wondered how could this simple shadow of brilliant green on this plastic sheet show the effect of the relaxation workshop I had attended just moments ago. My attention was diverted to the bright red aura photo being held in front of me. The photographer handed the photo to a teenage boy and said it looked like he was into sports, the boy nodded agreeably. This was interesting. If this could be as accurate for me as it was for the boy, maybe I could learn something about myself. I sat down to get my photo taken, and in a moment the colorful photo was in front of me. The photographer looked at the colors and said, "you are really relaxed, and look, see the different colors on each side? This means you are going through a change." An older woman interpreted the photo for me, and I discovered how accurately the colors described myself, my personality, what I was doing at that time in my life, and predicted my present occupation.

I was amazed that all this information was revealed to me through the little, brilliantly colored aura photo. I was immediately fascinated by the possibilities of this new technology. A further

development of Kirlian photography (also explained in this book), Aura Imaging Photography made it possible, for the first time, to display the energy field around the body in color.

My astonishment with the aura photo led me to take an aura workshop where I discovered I had the ability to see peoples' true colors;. Immediately, my life changed. My finances started improving because I learned, through the aura photo, which occupations would better suit me, and I began making business and career changes. By studying the meaning of my aura colors my social life also livened up as I learned more about my true personality and what people I would be more compatible with. I was then able to enrich my life with people I really enjoyed. My ability to interpret the different aura forms and the significance of the colors in the aura has helped me to understand how I relate with people, how I unconsciously process information and feelings as I go through changes in my life, and what my natural talents are.

My purpose in writing this book is to first explain to readers what this wonderful technology is all about, what exactly an aura is, and then to introduce how reading a photo and understanding what one's auric colors mean can help an individual in better understanding one's self, relationships, to define special talents, and clarify goals and aspirations. In simple terms, I want to illumine the topic of Aura Imaging Photography in theory and practice. I have deliberately avoided complicated terminology and tried to describe scientific topics in lay person's language. Many areas could only be explained briefly. If you would like deeper knowledge of specific areas, I recommend the books listed in the bibliography.

Also, I want to emphasize that all the colors have their unique and special qualities and that none of them I are either "good", or "bad", but are just characteristics and mirror what one is experience. throughout the text I refer to white and violet as being of a higher vibration. This does not mean that these are better colors, or that the people with these colors in their aura photo are more evolved. These colors just vibrate at a higher frequency than the warmer colors, orange, yellow, and red.

Of course, this book can only be an introduction to this new field. Since we have been working with Aura Imaging Photography for a relatively short time, we will have to wait for further developments until we are able to apply this technology to therapy and healing. Aura Imaging Photography promises to be an important tool and learning instrument for the development of consciousness.

The Hospital Of The Future

You sprain your shoulder playing a virtual reality game, and you are whisked to the hospital in the subway tube. A psychic nurse greets you as she looks over your aura at the same time maintaining a verbal dialog with her computer. It only takes seconds for her to enter her observation into the computer. She comes close to you and waves her hand over the affected area with sweeping motions, wiping away some of the pain psychically. After the pain subsides somewhat she tells you it's a mild sprain and sends you to the x-ray room just to be sure. After your x-rays are completed, you are taken to the aura imaging room. The medical doctor comes in with the x-rays in his hand, looks at

the film, and says the psychic nurse's diagnoses were correct. He then points out the area of the sprain in the x-ray, and asks you to stand in front of the aura screen. The machine comes on, you look at the screen around your shoulder and see the red colors of pain flashing around the injured area on the screen. The nurse comes in, and standing near you she holds her hand a few inches from your shoulder, and instantly you see the colors on the screen smooth out and glow a healing, emerald green. At the same time you feel the pain subsiding, the doctor writes you a prescription for a pain reliever while the nurse fits a sling for your arm. The doctor says "come back in a few days for a check up", and you are asked if you would like to go to a karmic counselor to work out the psychic cause of your injury, and then you are dismissed.

This event may sound like it's happening hundreds of years in the future, but this could really happen much sooner than you think. The technology is already here. There are many psychics capable of seeing auras, and many more being trained to see auras in workshops and aura seminars each year, while more and more people are using aura cameras. This technology will become an invaluable tool in both medical and psychiatric healing in the not too distant future.

II. Electrophotography

Kirlian Photography

Kirlian Photography or the recording of electrical energy fields on undeveloped film is not new. Long before Semyon D. Kirlian began his work in the 1930s and 1940s in Russia, scientists had already dealt with electrophotography. Michael Faraday, Nikola Tesla and Thomas Edison are only a few of those who came across the mysteries of a subtle energy body and the human aura. Around the turn of the century, Nikola Tesla took pictures not only of finger tip auras, but also of entire body auras.

In the forties, the first experiments regarding an energy body were undertaken. This energy body is a subtle field that surrounds living organisms. Since then many researchers and scientists have dealt with this topic. Probably the best known is the Russian S. D. Kirlian who developed Kirlian photography, a technology with which he was able to record subtle energy fields around living organisms.

Electrophotography usually refers to a phenomenon known as "corona discharge." The corona is the result of electronic discharge, and millions of electrons are displayed. These electrons move from the object to the photographic plate. Depending on the kind of film and electrical generator, beautiful colors and discharge patterns can appear.

In Kirlian photography, the subject puts the hands, usually together with the feet, on a plate which is connected to a high frequency generator. For a short moment, the hand is exposed to high frequency rays,

through the plate. The reaction of hand and feet is recorded on photographic paper. After the development of the film, the Kirlian photo looks like this:

Each finger tip has firm contact with the high frequency plate, and each tip displays an emanation. How can this corona discharge be explained? Why does this pattern develop around the fingers?

From acupuncture we know that many energy pathways run through the entire body. We can imagine these meridians as a system still subtler than the nervous system. Certain central points on the skin and the end points of the meridians are known as acupuncture points. These points resonate with the different organs. By stimulating them with an acupuncture needle or by acupressure (gentle pressure massage), the respective organs can be recharged with vital energy, also called "chi." For example, stimulating an acupuncture point of the liver meridian with a needle or by pressure activates the liver as well as other body parts connected to this meridian.

Kirlian photography was able to confirm this knowledge from Chinese medicine. It showed that certain resonance points in the hand, or rather the finger tips, are connected with the respective acupuncture pathways. When we discover irregularities in one area on the Kirlian photo, we can conclude from the resonance points of fingers or hand that energy is congested in the body. In our example: If the area of the liver point shows little or very strong emanation, we can assume that the energy of the liver meridian or other connected body parts is congested.

One of the most interesting phenomena in electro-photography is the "phantom leaf" effect. Several

researchers, including Allen Detrick and I. Dumitrescu, discovered an energy field around living organisms. When they cut a leaf in half, they were surprised to find that they could display around each separated half an emanation in the form of the whole leaf. Even if a physical part of the leaf was no longer present, a subtle energy field continued to exist in the same form as the original leaf.

Some theories say that the so-called "phantom limb" pain could be a similar phenomenon. After an amputation, many people still feel pain in that area. Although the physical limb no longer exists, the energy field, determined by Kirlian photography, seems to continue to cause pain.

Although Kirlian photography has been researched and applied for more than fifty years, many secrets have not yet been explained. The functioning of Kirlian photography is as follows:

Kirlian photography visually represents the ethereal and the physioelectrical body of a human being. It shows how the body reacts to electrical stimulation, and it records these changes on film. As in iridology and reflexology, Kirlian photography uses the reflexology points to show organic conditions in the human body. Since a blocked or weakened organ is equivalent to a blocked nerve, only a small or no electrical change would be displayed in the reflexology points.

So the photographed object and the used frequency of the Kirlian device must resonate with each other. In the phantom leaf effect, the produced frequency and the ethereal energy field resonate. The ethereal structure is associated with a higher vibratory

spectrum, a higher octave, than physical matter. Nevertheless, when applied correctly, Kirlian photography is able to display the ethereal energy.

This process is better understood in the following example. When playing the low C on a piano, this string vibrates in the respective frequency. This vibration causes other strings in other octaves to vibrate. So when we play the low C, the high C will also vibrate, as an overtone. Kirlian photography applies this principle. The electrical energy causes the electrons in the octave of the physical matter to move. At the same time, one octave higher, the resonating tone is stimulated in the ethereal energy field. So Kirlian photography displays the interaction of the ethereal field with the electrical field produced by the Kirlian camera.

In recent years, many physicians, naturopaths and therapists have used Kirlian photography for diagnosis and disease prevention by recognizing energy congestion at an early stage. It has been proven that both outer and inner factors (like negative and positive thinking) strongly influence our energy system. For further studies, I recommend the books by Peter Mandel. He developed his own diagnostic system, the energy point diagnosis, a further development of Kirlian photography. Mandel's system has been very successful.

Aura Imaging Photography

Electrophotography displays the corona discharge, which is the way the physical and ethereal bodies react to an electrical high voltage potential. A trained user of Kirlian photography can describe from these

photos precisely where energy imbalances, and therefore physical problems and diseases, are located.

To briefly summarize the important points about the subtle energy fields: humans are usually not able to transcend the limitations of their five senses. They cannot perceive the subtle energy fields. However, there are many people who are able to feel or see the aura. Depending on the abilities of a clairvoyant person, he or she can perceive different areas of the subtle energy field. Without knowing it, many people can partially see the ethereal field. This biofield emanates from the body for about one-half to two inches.

The next step would be to perceive the human electromagnetic energy field. The electromagnetic energy field arises from the flow of energy streams in the body. When we speak about the aura, we speak mainly about this part of human existence. Often the higher dimensional human bodies are also called "aura." We differentiate and use the terms "astral/emotional body," "mental body" and "spiritual body." The higher energy bodies reflect the emotional, mental and spiritual aspects of our personality. We can influence them through continuous, conscious change of our behavior. Individuals with very unbalanced emotional lives can mature into emotionally balanced personalities by increasing their awareness and by using appropriate therapies or meditation, although this personality change is a process that requires time.

The electromagnetic field reacts faster to inner and outer influences and therefore changes more frequently. The form and color composition of the aura can vary according to the state of mind or mood.

However, it rarely makes extreme changes within a short period of time.

Since the electromagnetic energy field is connected to the higher energy bodies, it can indicate the nature of body, mind soul, and can inform us about personality traits, feelings, talents, desires and energy patterns. The physical, mental and spiritual planes of every person have an individual vibratory rate. Therefore different colors or color combinations of the respective vibratory planes reflect these three personality planes.

The Development of the Aura Camera

An American research institute developed tests to measure the electromagnetic field. One wanted to register the reactions of a subject's palm with an electrical sensor. A medium or gauge seemed necessary to measure an energy field that exists momentarily around the body. It seemed obvious to use the hand as the measuring medium. From acupuncture we know that energy pathways, the meridians, run through the entire body. The meridians are connected to all parts of the body, including the different organs. This knowledge is used in reflexology to balance and harmonize specific organs. This is done by pressing and stimulating the reflexology points. The hand, as well as the foot and ear, contain the subtle energy points from all the organs of the body.

The subjects were led through different emotional and mental states, visualizations and memories, such as accidents and childhood experiences. As they were asked to concentrate, during the tests some clairvoyant people could see a person's aura and observed color

and form compositions and changes. A series of experiments established a connection between certain resonance points in the hand and the aura. Not only are the organs connected through the reflexology points in the body, but also the human energy field is connected to certain corresponding points in the hand.

Inspired by these test results, the Aura Imaging Systems were developed. For the first time, it was possible to generate a photographic representation of the aura. This is not a high frequency technology but an optical measuring procedure.

Fine sensors scan and measure the electromagnetic energy field of the hand. The measured values represent different vibratory rates and thereby different colors. The information is then transferred into the camera and translated into the corresponding colors. The resulting color combination corresponds exactly to the unique energy field of a person. The optical system then produces a high quality Polaroid photo which displays the individual's colors.

In the following chapters, we will more deeply explain the scientific and esoteric principles pertaining to the use of Kirlian and Aura Imaging Photography, what exactly an aura is, color definitions, and how to interpret an aura photo. New technologies are currently under development to help us track these constantly unfolding phenomenon.

III. Electricity and Magnetism

The existence of a subtle, non-material energy field around the human body has long been suspected, but has not yet been recognized by orthodox scientific circles. Nevertheless, many phenomena can only be explained in terms of etheric energy. In recent years, publications have increased on subjects like "electromagnetic energy fields," "auras" and "energy medicine." Frequently the usefulness, but also the dangers, of electromagnetic energies and even subtler powers are referred to.

This chapter explains the structure of our human nature in simple terms. Much of what is presented here is a summary of our current knowledge. Much research and development in the area of subtle energies will begin in the next few years. The following topics could become particularly significant:

• How can we influence diseases positively and harmonize our environment through the application of new technologies involving the subtle energy fields?

• How harmful is the effect of "electro smog" on our health?

• What are the principles of the subtle energy bodies, and how exactly do they manifest?

These are only some of the possible questions to which the answers are already partially known. This chapter begins with the basic phenomenon the principle of the two poles. Any physical life can exist only by the interplay of two polarities. In our life, one of the many manifestations of this state appears in the principle of electricity and magnetism.

Electricity has been commonplace in our world for almost a century. It serves us daily in all areas of life. We use it not only in our households, offices, factories, cars and airplanes, but we also find it in ourselves, in our physical, emotional and mental existence.

Where Does Electricity Originate?

Physics has known for many years that flowing electrical current generates a magnetic field. When a vibrating, pulsating magnetic field exists, there must also be an energy flow in an electrical conductor. The simplest form of electricity is caused by the movement of electrons in a medium. That means, we have to deal with the smallest particles of matter in order to understand the laws of electricity and magnetism.

In classical physics, an atom is regarded as the smallest whole unit of physical matter. The atom consists in its ground state of specific particles — the electrons, protons and neutrons. The number of electrons, protons and neutrons in an atom signifies and differentiates one element from another. Accordingly, a hydrogen atom has a different composition of particles than an oxygen or helium atom. If we could look at an atom, we would see the electrons orbiting the nucleus, which is composed of neutrons and protons. When several atoms connect, we get molecules. Molecules can form cells. The cells, the main building blocks of our bodies, finally form organs.

Let us now look at the structure of an atom (Illustration 1). The orbiting electron possesses a negative electrical charge, the proton in the nucleus a positive charge and the neutron does not show any

charge. As already mentioned, the number and position of the electrons and protons distinguish one element from the other. The electrons orbit in specific formations and distances around the nucleus. We could compare them to the planets which circle our sun in fixed orbits. We will illustrate this fact more precisely with the simplest example, the hydrogen atom. This atom has only one proton in the nucleus and a single electron.

Illustration 1

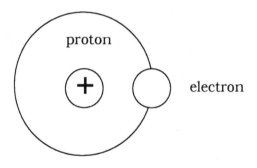

Hydrogen Atom

On the macroscopic level, we could compare this atomic process with the orbit of the moon around the earth. The earth would be the proton and the moon the electron. Just as in an atom, the moon (electron) moves around the earth (proton). From our perspective the main difference would only be that the electron in the atom travels with greater speed than the moon around the earth. It is not possible for humans to follow the movements in an atom, since human perception is limited by our five senses.

Having considered the smallest particles of matter, we can now go one step further. When we take a wire and connect it to a battery, we observe the following processes:

Illustration 2

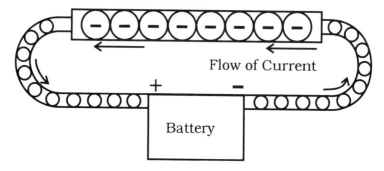

Current in a Battery

Like all matter, the wire consists of atoms and therefore contains a certain number of electrons. The battery, which shows a plus and a minus pole and therefore an electrical current, possesses extra electrons. These electrons flow through the wire from the negative to the positive pole of the battery. In physics this process is governed by the following laws:

- Electrical current flows from one side of the battery to the other.
- At a right angle to this energy flow, a magnetic field emerges.
- The resistance within the wire to the flow of electrons generates heat.

Illustration 3

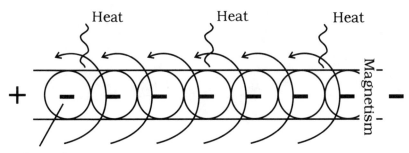

Enlarged View of a Wire

Electrical energy flows also in humans. When applying this example to our body, we can imagine the brain as a kind of battery, the digestive tract as the battery charger, and the body with its nerves and energy meridians as conductors of electrical energy. When we take food, the organism absorbs, among other nutrients, minerals. The minerals are absorbed in the small intestine and the colon. Due to the chemical process of electrolysis, the minerals produce a current in our brain. The brain finally conducts this electrical energy through the nervous system where it functions as the driving force necessary to perform all bodily functions. If the colon or other participating organs do not function properly, the current, or rather the electrical potential of the brain, decreases and we become tired and lethargic. Through the energy flow in the nerves — a form of electricity much subtler than ordinary current — a magnetic field develops around the body, just as in a wire. We will describe this in more detail later. For better understanding, we will

now look at the nerve as an example of electrical
distribution (illustration 4).

Illustration 4

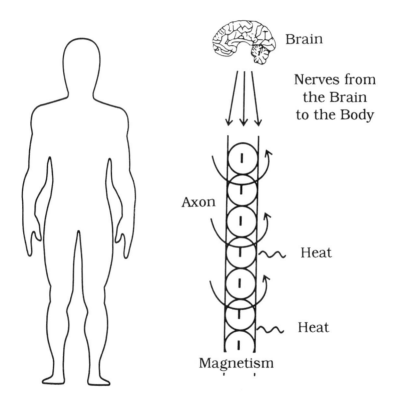

This principle of energy flow between two poles is
universal, whether it concerns a wire or a nerve fiber.
Through the energy flow, a magnetic field develops
around the wire. The more current flows in the wire,

the stronger becomes the magnetic field. Each flow of electricity and each magnetic field possesses a specific alignment and strength. As we all know, the alignment of the magnetic field is determined by the north and south poles. The part of a magnet pointing north is called north pole, the part pointing south is called south pole (Illustration 5).

Illustration 5

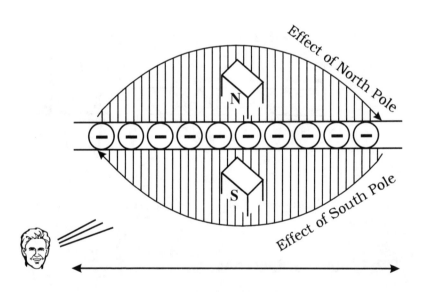

One revolution per second

Each magnetic field and each electrical flow is characterized by a specific fluctuation, a pulsating motion. So a magnetic field can show a frequency of one revolution per second or one thousand revolutions per second. When, for example, a generator producing

a magnetic energy field performs one complete rotation around itself (360 degrees) in one second, this motion is called one revolution per second. The scientific expression for this process then is: a frequency of one hertz (1 Hz).

Doubling the speed of the generator results in a frequency of two revolutions per second (two hertz).

Illustration 6

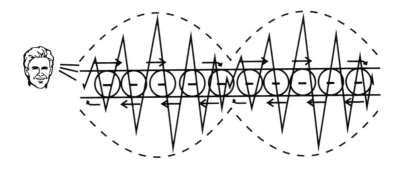

First revolution Second revolution per second

The Frequency Spectrum

Rotating a generator or an appropriate medium generates electricity. The frequency is determined by the number of rotations. Scientists have been aware of these different frequencies for many years. The entire range of electromagnetic fields or waves, from the lowest (like millihertz) to the highest (like quadrillion hertz and more) is called the frequency spectrum.

Illustration 7

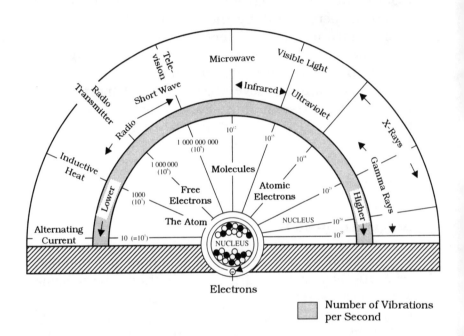

The Large Spectrum of Electromagnetic Radiation

The lowest range of the frequency spectrum is called the ultra or low frequency range. Researchers discovered that lower life forms, like single-celled and multi-celled organisms, bacteria, viruses and fungi, vibrate in this frequency range. These vibrations are also responsible for processes like the rotting of fruit. Some household appliances and engines are powered in this low frequency range of about fifty to sixty hertz (that is fifty to sixty revolutions per second).

If a generator would produce 100 to about 16,000 revolutions per second, or if we had a medium which vibrated in this frequency range, we would get a sound spectrum perceivable by the human ear. To produce this, a strong enough electrical energy causes air molecules to move. We perceive the sound through the membrane of the ear. Air molecules also move at higher revolutions, above 16,000 Hz, but most people cannot hear these sounds. Some animals, like dogs, have an extended hearing ability. After a siren has finished and is no longer audible for humans, dogs will still bark because they continue to hear the sound vibrations.

Higher Frequencies

As soon as a frequency of 500,000 to 1,000,000 revolutions per second (Hz) is reached, wave forms with very short wave length are produced. If the voltage potential is high enough, the generated energy exerts strong pressure or tension on the wire. The wave form can no longer be kept in the wire. The wave now expands and travels into free space. This process is used with radio waves: different types of radio bandwidths (like long and short waves which occupy different frequency ranges) are used for broadcasting programs.

Visible light also occupies the small range of the frequency spectrum perceived by us. Light is an electromagnetic vibration with specific wave lengths and frequencies. With our physical eyes, we can see only a small fraction of the known frequency spectrum. Vibrations above or below this frequency range are not registered by the human eye. Some

insects and other animals see several million cycles per second beyond what is possible for humans. They are able to register optically the range of X-rays, gamma rays and still shorter rays. When we leave the spectrum to the right side (Illustration 8), the vibratory range of X-rays and gamma rays, we enter the ethereal, subtle area.

With our five senses, we are able to perceive a small range of the frequency spectrum. This is what we call reality. In addition to the sound spectrum, we are able to recognize different light vibrations. With our eyes we perceive the different vibrations as colors. Normally humans can see the range from red to violet in the light spectrum. Some animals, like bees, are able to penetrate even into the ultraviolet range.

Illustration 8

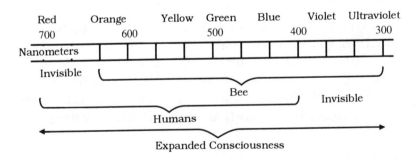

Visual Perception of the Electromagnetic Spectrum

It is fascinating to view the innermost aspects of our body. Like all matter, our body and our organs vibrate at a certain frequency. First we will consider

the subatomic realm by examining an atom in more detail.

An atom vibrates at a frequency of about 1015 Hz (a ten with fifteen zeros) and the nucleus of an atom vibrates at a rate of about 1022 Hz; these vibratory rates are unimaginably fast. Stated simply, we could say that when an atom vibrates 1022 times per second back and forth between two poles, it's as if it said: "Yes!, No!, Yes!, No!..." 1022 times per second. Our senses are far too slow to process this information.

When atoms combine into molecules, the vibratory rate decreases and mass increases. Molecules vibrate at a speed of about 109 Hz (gigahertz range). From molecules, living cells are formed, and cells constitute our organism. Cells have a far lower vibratory rate (about 103 Hz) than atoms or molecules. The deeper we penetrate into the inner world of humans, into the subatomic realm, the higher are the vibratory rates.

This simple description of electrons and protons, electricity and magnetism should not hide the fact that ultimately, modern science knows very little about these phenomena. Nevertheless the frequency spectrum clearly shows that humans can only perceive a tiny part of reality through their five senses.

Mutual Induction and Resonance

To find out how vibrations work in ourselves, we have to understand another basic principle of physics. For example, if you hang up washing on a rainy day near a power line that runs parallel to the clothes line, you may get a small electric shock when touching the clothes line.

Illustration 9

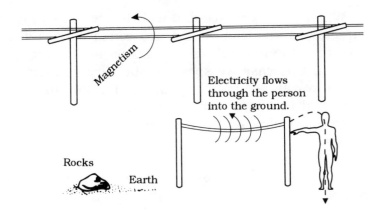

Because of its high intensity, the magnetic field of the power line spreads to the clothes line. The clothes line, due to the high humidity, has adopted the conductivity of a wire. Electrons flow in the line and at touch discharge through your body into the ground. This principle is called "mutual induction." It is also found in our body. We possess thousands of small nerves which conduct electricity. Each of the individual magnetic fields interacts with the next field. Mutual induction brings about an extremely powerful magnetic field.

The term "resonance" is very significant in electro-magnetism. It describes an object's ability to vibrate when stimulated by mutual induction. Let us illustrate this with another example: We have two violins, tuned exactly the same. While one violin lies on the table, we play a note on the other one. When we pay close attention, we will find that the same string we are playing on one violin begins to vibrate on the

other one lying down. Resonance, a common vibration, exists between these two strings.

When we bow a string, it will vibrate in its natural frequency. Since the violins are tuned correctly, we know that the natural frequencies of both strings are equal. In this case we speak about "acoustic energy." The air waves generated by the first violin spread in space and influence the second violin. The string of the second violin, which is tuned to the same tone as the first violin, reacts to the energy waves, since the frequencies are identical. Another string will not react to the air waves since there is no resonance with the tone played.

The principle of resonance is closely related to the principle of octaves or overtones. Again we use an example from acoustic energy. When we strike the middle C of a piano, the string will vibrate with a frequency of 264 Hz. When we remove the piano's cover, we can observe that the string one octave higher than the middle C will vibrate strongly as well. This string will vibrate at exactly twice the frequency of the string struck (528 Hz). Other strings also vibrate in resonance with the played middle C. The string half an octave higher than the middle C, the note G, vibrates at a frequency of 396 Hz. Some other strings are influenced as well, but with less intensity. We see that when only one string of a piano is struck, resonance causes several other strings to vibrate also, each at a different frequency. Trained listeners can perceive these overtones.

The principle of resonance applies not only to tones, which are just one form of vibration. Resonance is also one of the most important laws for energy phenomena. In the chapter on electro-photography or

Kirlian photography, we will see that resonance also exists in our bodies—between the physical, the mental-spiritual and the ethereal-astral bodies.

Resonance is also part of human relations. Statements like: "I feel attracted to this person," "We understand each other, we harmonize well together" or "We are on the same wave length" demonstrate that the principle of resonance applies not only to the physical-energetic but also to the emotional, mental and spiritual realms.

Vibratory Fields in Humans

Let us take a trip through physical matter to unveil its secrets. We use an imaginary super microscope with which we can observe even the smallest atom. In a piece of muscle tissue, we can discern with a little enlargement the individual muscle fibers, the blood vessels and finally the cells. The more we enlarge, the more we can differentiate the neatly organized micro structures of the tissue. A stronger enlargement shows that the cells consist of long, spiral molecular chains in which entire groups of atoms revolve. This dance of the atoms in the molecules proceeds in clearly structured formations and in enormously fast but constant movements. The high speed of the atoms generates vibration.

When laying a magnet or an electrical field on muscle tissue, we observe through the microscope an immediate change in the atoms' motions. The magnetic field influences the course of the electrons and their relationships to each other.

Now, looking at an individual atom more closely, first it appears as a fuzzy, tiny tangle in a vast, empty

space. However, the more this tangle is enlarged, the less we can differentiate. The oscillating shell of electrons has finally dissolved into nothing. We find ourselves in a completely empty space - a vacuum. By greatly enlarging this empty universe, a hardy, perceivable ball — the nucleus becomes recognizable. By enlarging the diameter of the nucleus to one foot, the diameter of the electron orbit grows to about 10,000 feet, a proportion of 1:10,000. The remaining space in-between is a vacuum. If the nucleus is enlarged with the super-microscope even further, it would suddenly seem to disappear. All that would be visible is a shadow-like pulsation of an energy field.

What happened to the muscle tissue? Didn't the experiment start with apparently solid matter?

Illustration 10

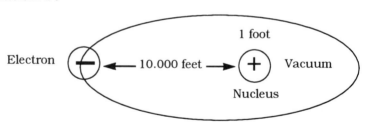

The findings of subatomic physics have shown science that solid matter is nothing more than empty space filled with oscillating, vibrating energy fields, all influencing each other.

On the subatomic level, everything is vibration. The slightest change in one energy field causes changes in all other vibratory fields. A network of energy fields exists. All of them are pulsating together

in harmony, but each at its own vibratory rate. Harmony here is rhythmical togetherness of the fields.

If an outer influence disturbs the natural harmonic rhythm of these energy fields, all other neighboring fields will also be influenced. We can compare this to a musical piece played by a large orchestra. When one musician loses the rhythm and plays off key, wrong notes, the other musicians will probably also lose the rhythm. After a certain time, the pleasant sounding concert has turned into a cacophony. A good conductor is able to detect and remove the source of the disturbance. Through his strong influence on the orchestra, he can then reestablish rhythm and harmony.

Our human body functions like an orchestra. Health and well-being equate with harmony among the body's diverse vibratory fields. A disturbance or disharmony causes unease. When more advanced, it weakens the immune system or produces illness. If one part of the body loses its harmony, the entire body suffers. As Dr. I. Dumitrescu says: "We can understand disease as a battle of vibrations."

We can interpret disease as out-of-tune behavior of one or several organs of our body. When a strong, harmonious rhythm influences an energy field that has lost its equilibrium or rhythm, the harmonious influence can reestablish order and balance in the system.

Recent research and experimentation has also proved that the human vibrational field can be measured and evidenced in scientific terms. Dr. Valerie Hunt, and other scientists from U.C.L.A. have completed a fascinating study on the human energy

field and its relationship to neuromuscular and emotional energy, finding, in brief, that the auric field psychics and sensitives have seen and reported throughout history can be scientifically proven with the electronic evidence of frequency wave patterns.

By using talented clairvoyant aura readers who read the subjects' auric fields while reporting what they saw into a tape recorder, the scientists were at the same time able to measure the energy fields with a Fourier Analysis and a Sonogram Frequency Analysis.

The frequencies and wave forms corresponded with the patterns and colors the psychic aura readers saw clairvoyantly. The results of Dr. Valerie Hunt's study proved that certain colors correlate with specific frequencies, with the color blue having to the slowest frequency, and violet and white having the fastest.

Summary:

- The flow of energy between two poles causes an electromagnetic field.
- Human beings can perceive with their five senses only a small fraction of the frequency spectrum. What we consider reality is limited by our perception.
- Any matter is empty space, a vacuum, imbued with vibrating energy fields.
- Harmony in the vibratory fields expresses itself as health, disharmony as disease.

IV. The Physical Plane

Please imagine the following scenario: going back several thousand years in history, there are no cars, no airplanes, no electricity, no generators, no gas stoves, no hydroelectric power stations. But the people of that time know the secret of fire. One day, a particularly intelligent Stone-Age person tells his tribes people that he has discovered something completely revolutionary. He puts forward the bold assertion that he is able to produce steam out of water.

To his tribe this assertion is outrageous, impossible, unimaginable and scientifically incomprehensible. Most people ridicule the Stone-Age scientist and some call him "nutcase" and "dreamer." Nevertheless a few people are interested in this novelty. They watch a demonstration of the experiment to find out if his claim is correct. The scientist puts a container with water on a fire and says that now they only have to wait a while. Some of the spectators find that much too simple. When nothing has happened after a few minutes, they leave, confirmed in their belief that it is only a fraud. But the others wait, and behold! After some time, a bubble can be heard. The water is boiling. As if produced by invisible hands, a fog-like substance rises. Some viewers are confused and assume that the scientist is using some kind of magical powers. But the rest of the spectators are thrilled. They learn to reproduce the experiment and to handle the new form of energy. They leave, ready to spread this knowledge to the entire world.

After a large number of people have seen this experiment of producing steam, the masses accept it.

This story has certainly happened from time to time in similar forms. The Wright brothers, Leonardo da Vinci, Newton, Nikola Tesla and other brilliant scientists were not accepted at first. Sometimes their peers even fought them. Nevertheless, progress could not be blocked.

This short story illustrates that a basic prerequisite for exploring new dimensions of knowledge should be intellectual openness, an inquiring mind coupled with a healthy amount of skepticism and the ability to critically analyze, although criticism should not degenerate into ignorance and lack of interest. True science explores phenomena, whether or not it fits into a prevailing world view, and while judging unbiasedly, attempts to integrate the newly acquired knowledge into daily life, for the benefit of everyone.

Solid and Subtle Matter

That our matter has a subtle aspect is not a new idea. In the nineteenth century, phenomena were discovered that pointed to the existence of a biofield, or ether, an energy invisible to our eyes. Researchers like Wilhelm Reich, who developed the orgone energy theory, and Nikola Tesla, who tried to utilize this energy in experiments, were precursors in the area of subtle energies.

The first scientific experiments regarding an energy body, that is, a subtle energy field surrounding living organisms, were undertaken in the 1930s and 1940s by Dr. Harold S. Burr at Yale University who studied the forms of energy fields surrounding plants and animals. To verify electrical energy fields, Burr used ordinary voltmeters to take measurements on the

skin. Working with the energy fields of salamanders, he was able to determine a direct current potential that was aligned with the brain and the spine. Dr. Robert O. Becker conducted similar experiments and was able to confirm and even expand Dr. Burr's results. In salamanders he measured electrical direct currents which seemed to indicate a connection to the nervous system. Each mass of nerve cells showed a positive, and all their nerve endings a negative, electrical potential. Dr. Burr also found that young salamanders were surrounded by an electrical field of the same size as an adult salamander.

Illustration 11

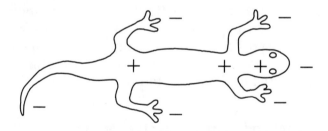

Salamander

Dr. Burr's research also dealt with tiny sprout seeds. He found that the electrical field surrounding the sprouts did not correspond to the form of the seeds but already to the form of the grown plant. Burr concluded that the growth of every organism is influenced by the electrical field that surrounds it. Further experiments in the late fifties in bioenergetic growth fields confirmed these research results.

Electrographic photography, which is related to the electromagnetic energy fields of living organisms, has become very well-known by now. In the early forties, when Dr. Burr conducted his measurements in the USA, the Russian researcher Semyon Kirlian dealt with a similar phenomenon. He developed a technology of photographing living organisms in the presence of high frequency, high voltage and low amperage electrical fields. Kirlian and Burr both studied the same electromagnetic field of living beings. With his special electrographic technique, Kirlian succeeded in displaying these electrical fields on photographic paper.

Both Burr and Kirlian were able to prove in the forties that all living organisms are surrounded by a subtle energy field. Both scientists also found a connection between disease and changes in the organism's electrical field. Since Kirlian's first experiments in electrophotography, many scientists and researchers have advanced this area and gained new insights into electromagnetic energy fields. But we are still only at the beginning, and need much more research.

The Structural Plan of Physical Matter

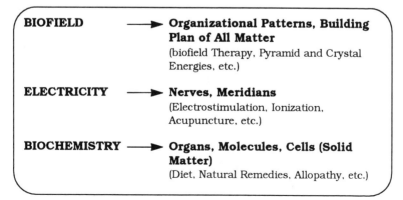

BIOFIELD	➤	**Organizational Patterns, Building Plan of All Matter** (biofield Therapy, Pyramid and Crystal Energies, etc.)
ELECTRICITY	➤	**Nerves, Meridians** (Electrostimulation, Ionization, Acupuncture, etc.)
BIOCHEMISTRY	➤	**Organs, Molecules, Cells (Solid Matter)** (Diet, Natural Remedies, Allopathy, etc.)

Let us start with the plane known to us—the bio-chemical. During the past decades science has gained many insights into the physiological processes of the body. Today we know precisely how specific molecules and cells react chemically. Genetic engineering enables us to penetrate even deeper into the secrets of the body's structure. But this is a very controversial field. It has dangerous and unpredictable aspects and therefore requires high ethics.

The research of many scientists, Dr. Harold S. Burr and Dr. Robert O. Becker among others, has proven a direct current system in the body. This electrical system also functions with the subtle energy pathways known from acupuncture. Through the meridians and nerves, electrical energy is sent and distributed to all connected parts of the body. We know today that not only high electrical voltage can cause significant changes in the body, but also low, subtle current which is adapted to cell communication. Different instruments were used to prove the existence of an electrical energy system in the body and to research the effects of different materials and magnetic fields on the body, like the Nuclear Magnetic Resonator, the Squid, electronography and biophoton research. The section "How the Aura Originates" will go into more detail.

From the healing of bone fractures we know that electrical signals are critically important in the recuperative process. The research of Dr. Burr and Dr. Becker confirmed, for example, that an overall plan exists in the salamander that teaches the body to build and regenerate itself. Therefore, in addition to the electrical plane, an even subtler plane must exist, a plane which carries information.

This biofield seems to contain the organizational patterns and the building plan from which the physical realm is constructed in all its details. This subtler plane was given many different names in the course of history: radionic, psionic, scalar waves, ether, bioplasma, chi, orgone, precursive energy (preceding the physical) or biofield. Since we are dealing with a completely new spectrum, conventional instruments are presently not able to measure these biofield phenomena. But in many cases, it is possible to explain processes not understood by orthodox physics.

Many physicians and naturopaths have had very good experiences with holistic treatments. They treat several planes of the human being simultaneously. Dr. Fred Bell, specialist in subtle energy systems, describes his experience as follows: "Out of ten people whom I treat with biochemical methods (like allopathic, natural remedies and diet), an average of three people respond well. When working additionally on the electrical plane of the body (for example, with ionization and electrostimulation), the success rate increases to about sixty percent. But in many cases, the cause of the problem lies neither in the biochemical nor the electrical system, but in the biofield. The biofield precedes the other planes and is responsible for the formation of physical matter. We could say that it establishes specific parameters, so that electricity can flow in the body and cells and organs can form. When dealing with the biofield, in addition to biochemistry and electricity, I can score a hundred percent success with most patients."

The Biofield or the Ethereal Body

For thousands of years, Chinese and Indian medicine has considered the subtle aspect of the physical plane as real, and has included it in the treatment. There the term "ethereal body" is often used.

In short, the ethereal energy flow is invisible to the human eye, as is electricity in a wire. But this invisible aspect of our body is very important because it affects the vital energy that keeps us alive.

Here is a model that shows the structure of the physical plane and the ethereal body.

Illustration 12

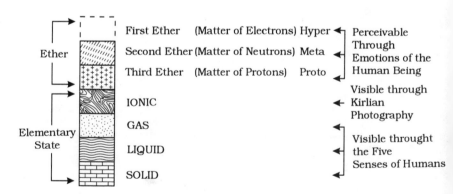

The following example demonstrates the different states of matter: We take a block of ice (solid) and put it in a pan on the stove. We turn on the burner. The emission of heat causes the molecules to increase

their motion. Soon water (liquid) develops. If the emission persists (in this case through the stove), the strongly heated water turns into steam (gaseous). When still more energy is supplied, the water molecules will split into H+ and OH-(ionic). These four are the most common states of the physical plane. In our Western world, we have sufficient information about the composition of matter in the solid, liquid, gaseous and ionic states. Most recently science has also dealt with the ethereal, that is the subatomic planes of matter. In the last few years, much has been written on the ethereal body and the subtle energy bodies (see bibliography).

V. The Human Electromagnetic Field

How the Aura Originates

Before dealing with the connection between colors and aura, the structure and functioning of an electromagnetic energy field must be explained. An electron flow in a medium (for example, electrical current in a wire or current in a nerve) causes a flow of electrical energy and a magnetic field. Both components, the current and the field, are linked to each other and are called "electromagnetic field." Different energy systems exist in our body which contribute to the formation of an electromagnetic field. Now we want to consider more closely how the body forms an electromagnetic energy field. Dr. Fred Bell describes this process in his book Death of Ignorance as follows:

In addition to nerves and blood circulation, many subtle energy pathways exist in the body. Chinese medicine describes 72,000 main paths — the acupuncture meridians and nadis. The nadis send electricity through the body, and millions of smaller pathways transport proportionally smaller amounts of energy. The primary pathways are the blood circulation, the meridians, the spine and the nerves. The spine is considered the main axis around which the electromagnetic energy field forms. The north pole of the human energy field is located in the brain ventricle, the south pole at the end of the spine. As already mentioned, magnetism develops at a right angle to the flow of the electrical impulses. Since the energy paths run parallel, they mutually induce and reinforce each other. This enlarges the electromagnetic

field. To maintain this process of induction and reinforcement, the energy currents must be in phase and in harmony. When we are in spiritual harmony with the universe, we reach phase coincidence, the harmonious flow of energies in the body. A person balanced in body, mind and soul has a larger electro-magnetic field.

The Spectrum of Consciousness

In addition to the gross aspect of physical bodies, a subtle realm exists. A subtle biofield penetrates all matter. This ethereal body is substantially responsible for well-being and diverse activities. The solid, physical body is nourished and formed by this more subtle energy field.

Although the ethereal body is usually invisible to the human eye, it is a substance belonging to the physical world. It only has a higher vibratory octave than gross matter. Often we perceive it subconscious-ly. It has been described as a fog-like, indistinct substance about one-half to two inches around the body. People with keener perception are able to recognize even more details and utilize them for therapy.

Humans, furthermore, consist not only of physical and ethereal bodies; they can feel, love, suffer and hope. They can think and analyze, have intuitive inspirations and understand mental-spiritual truths, so we have still other planes of impression and expression. These areas are the different areas of consciousness, or planes of being. The physical body serves as a kind of vehicle in which feelings (emotional body), thoughts, intuition (mental body) and spiritual

properties unite and express themselves on a material plane. Many ancient cultures and philosophies speak about seven subtle bodies, or realms of consciousness, that manifest in and around the physical body. It is the magnetic and electrical emanations of these subtle bodies of consciousness that form the human aura.

Illustration 14

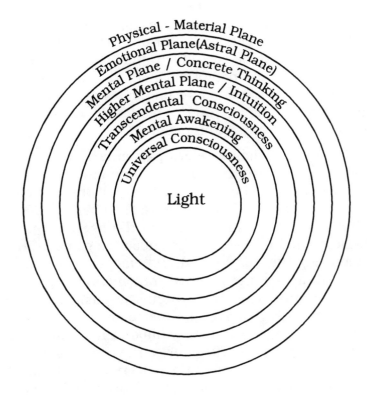

VI. Colors and the Chakras

The Energy Centers of the Body

Many ancient cultures speak of power points in the body through which energy flows and is transformed. The Hopi Indians of North America consider themselves the oldest inhabitants of the continent. In their world view the human body is built according to the same principles as the earth. Both have an axis. The North-South-Pole axis corresponds to the human spine; the North Pole to the brain, the South Pole to the end of the spine (see Illustration 18). The spine is responsible for the body's balance. Not only are most nerve points for the organs along this axis but also the subtle power centers, responsible for the regulation of the mental and physical functions.

Eastern medicine refers particularly to the significance of the ethereal body, or biofield, and its energy centers. The East Indians call the most important energy centers "chakras" ("chakra" means "wheel"). The chakras express themselves on the physical human plane in the endocrine glands. These glands regulate all physical and emotional processes. The chakras are the ethereal transition and transformation points through which the cosmic, higher frequency energies are channeled into the physical body. This vital energy is very important for our health and well-being. If the energy flow of a chakra is disturbed, the corresponding endocrine glands and all connected metabolic processes will become imbalance. We can then observe a chain of physical and mental functional disorders.

The seven main energy centers and their position in the body are shown in the following illustration.

All physical and subtle matter has a specific vibratory frequency. Just as radio and TV waves can coexist without mutual influence or disturbance, the different energy bodies of physical or subtle matter can coexist in the same space without problems. It is necessary that the energy flow of one plane be connected to the subsequent plane.

If one's different bodies of consciousness (emotional, mental and spiritual planes) were not interconnected, no information could be exchanged within these planes. We could not express our feelings in daily life, nor translate our intellectual and intuitive ideas into creativity. Like every system, the human body needs transition centers, or exchange points. In our physical body, the chakras (energy centers) serve as transformers. They transform the streams coming from the finer, higher frequency energy bodies (emotional-mental-spiritual), so that our physical body can utilize this adapted energy.

We can illustrate this process with an example from daily life: Large factory machines require electricity of 440 volts and more. For household use, the voltage needs to be reduced to 110. If you power a household appliance with higher voltage, it will quickly get damaged and finally break down. In our industrial society, electricity is mainly supplied centrally, one power company is responsible for a specific area. Through wire it distributes electricity to the houses and factories of that region, where the current is then adapted for the different purposes. The transformation of voltage depends on the need, for example 110 volts for household appliances and 440 volts for factories.

SPIRITUAL PLANE

Energy Transformation

MENTAL-INTUITIVE PLANE

Energy Transformation

EMOTIONNEL PLANE

Energy Transformation

ETHEREAL PLANE

Energy Transformation

PHYSICAL BODY
All Physiological Processes
(like Cell Division,
hormone Flow and
Nerve Functioning)

Similar principles of energy transformation apply to the human body. It may be easier to understand this concept if we imagine the different areas of human consciousness as real, existing bodies.

The energy generator that drives, enlivens and gives soul to our human system, lies on the spiritual plane of being. This spiritual body is also called the divine aspect in us, the connection to all-embracing creation. From this unity, energy flows to the other energy bodies, or planes of the human being. Each body has to fulfill different tasks and therefore requires a specific quality of energy, or voltage. On every plane, certain transformation points exist which

adapt the energy to the next plane. This example corresponds to the central electricity supply in a power station that serves as a switchboard. It supplies power with different voltages for different users (110 or 440 volts).

The entire universe is connected by a primordial power. This power is transformed according to the needs of the mental, emotional and physical planes. On its way from divine unity to the different planes of being, the primordial energy loses more and more of its strength and intensity. The closer we approach the physical plane, the more the vibratory frequency decreases, until we finally reach the frequency spectrum known to us—the physical body.

Research has already demonstrated these connection and transformation centers of the physical and ethereal bodies. It is possible to establish a direct connection between the nerves, the circulatory system and the acupuncture pathways, the meridians. Much research is in progress, especially in the area of energy medicine, and we can expect revolutionary insights in the next years.

Both humans and the universe consist of different planes — spiritual, emotional and mental. Human body and cosmic body differ only in their wave lengths, their frequencies. This means that the divine power is found not only outside but also within our own existence. Because humans possess the power of imagination, they can attune themselves mentally to the different energy bodies, or planes of consciousness, and change them. All methods that expand consciousness, including meditation, do this.

Chakras and Consciousness

Our consciousness can move within our multi-dimensional being through the different planes of consciousness. These changes can occur rather quickly and frequently. For this, the energy centers of the body are very important. Each chakra serves as a kind of sending and receiving station for specific areas of consciousness or vibration. When the attention is centered in one chakra, the person deals primarily with a "theme" associated with the respective chakra.

The Meaning of the Chakras

Through their clairvoyant abilities, the rishis of ancient India received knowledge of the human energy system. This science was then written down in the ancient book of knowledge — the Vedas. In India, like in many other old, wise cultures, the chakras were associated with certain colors, elements, symbols and properties. A certain vibratory affinity exists between these associations. For example: The sound of the word LAM (a mantra), together with the visualization of a gold-yellow rectangle (a yantra), produces a certain vibration. This, in turn, resonates for example with the earth element in the body, with the sex glands, the first chakra, the color red, the planet Mars and the gem ruby. When corresponding imbalances exist, the described technique can have a harmonizing effect. Certain meditation techniques utilize this knowledge.

When people are concerned mainly with physical things, with their daily problems of existence and material interests, their consciousness is centered

primarily in the first chakra. Their thoughts and feelings will be materially oriented, and their daily activities deal mostly with securing existence and survival. But even when the attention is centered in the first chakra, personalities and aura pictures vary greatly. Depending on its development, the personality can range from violent and destructive to physically active and full of the joys of life. The attention is still on the lowest chakra, but the quality or expression of energy can vary. In the human electromagnetic energy field, the first-chakra state of consciousness will be displayed in a reddish color. According to development and personality, a dark, dirty red to a bright, pure red can appear. Dark red can indicate an extremely material behavior or addiction to alcohol or drugs. Bright red in the aura usually indicates a sensitive person who copes with the environment but is attached to material things.

We have the same situation when individuals center their attention in the third chakra. The yellow which then shows up in the electromagnetic field can be dark-yellow to golden-yellow. Egotistic people who try to control and use their environment and other people, will produce dark yellow in their aura. Dark yellow has a limiting effect. A strong, charismatic person who is esteemed in the community probably also has yellow in the electromagnetic field. This yellow, however, will be bright and glowing.

All human energy centers function in this way. Each person dwells on a certain plane of consciousness, depending on the stage of development. This plane will show more intensely. The planes are connected to the electromagnetic field through the chakras. Physically and emotionally oriented people

will probably show more red, orange and yellow in their auras. Spiritual and creative people will show more blue, violet and white.

The following chart clarifies the connection between energy centers and specific human qualities.

First Chakra: Struggle for survival, basic needs, assertive power, relationship to earth

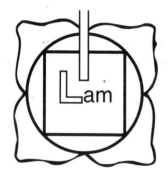

Main Color:	Red
Sense:	Smell
Sound:	LAM
Element:	Earth
Elemental Symbol:	Gold-Yellow Rectangle
Endocrine Gland:	Gonads
Body:	Reproductive Centers
Harmonious:	Vitality, Activity, Strong Sexuality, Ability of Discrimination, Stability
Disharmonious:	Sexual Diseases, Lethargy, Illusions, Strong Egocentricity, Severe Anxiety

Second Chakra: Emotions and feelings, sexuality, sensuality.

Main Color:	Orange, Yellow
Sense:	Taste
Sound:	VAM
Element:	Water
Elemental Symbol:	Silver-White Crescent
Endocrine Gland:	Adrenal
Body:	Blood and Lymph, Digestive Juices, Kidneys, Bladder
Harmonious:	Adaptability, Self-Satisfaction, Good Circulation
Disharmonious:	Poor Circulation, Kidney and Bladder Problems, Jealousy, Loneliness

Third Chakra: Development of personality, influence and power, active intellect.

Main Color:	Yellow, Blue
Sense:	Sight
Sound:	RAM
Element:	Fire

Elemental Symbol:	Red Triangle
Endocrine Gland:	Pancreas
Body:	Digestive System, Liver, Spleen, Gall Bladder, Bladder
Harmonious:	Courage, Creativity, Independence, Strong Personality
Disharmonious:	Problems with Liver, Gall Bladder and Eyes, Dependence, Arrogance, Anxiety

Fourth Chakra: Healing, love, devotion, care, selflessness.

Main Color:	Green, White
Sense:	Touch
Sound:	YAM
Element:	Air
Elemental Symbol:	Gray-Green Smoke
Endocrine Gland:	Thymus
Body: Circulation	Heart, Lungs, Skin, Blood
Harmonious: Romance	Love, Selflessness, Generosity,
Disharmonious:	Breathing and Circulation Problems, Asthma, Avarice, Egocentricity, Indecision, Anxiety

**Fifth Chakra: Expression, creativity,
 communication, inspiration.**

Main Color:	Light Blue, Blue
Sense:	Hearing
Sound:	- -
Element:	- -, Sky Blue
Elemental Symbol:	- -
Endocrine Gland:	Thyroid
Body:	Throat, Neck, Gullet, Speech Organs
Harmonious:	Good Communication, Expression, Creativity
Disharmonious:	Anger, Poor Communication, Aversion to Everything, Infections

Sixth Chakra: Intuition, mental and will power, knowledge.

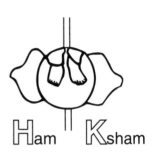

Main Color:	Indigo, Violet
Sense:	Intuition
Sound:	HAM-KSHAM
Element:	Ether
Elemental Symbol:	Sky-Blue Circle
Endocrine Gland:	Pituitary
Body:	Eyes, Face, Central Nervous System, Physical Balance
Harmonious:	Popularity, Intuition, High Ethics, Clarity
Disharmonious:	Dependence, Unfulfilled Desires, Indecision, Imbalance

Seventh Chakra: Knowledge and enlightenment, connection with higher planes of consciousness, spirituality.

Main Color:	Violet, White
Sense:	Attunement to the Divine Plan (Cosmos)
Sound:	OM
Element:	Space, Ether
Elemental Symbol:	Thousand-Petaled Lotus
Endocrine Gland:	Pineal Body
Body:	Brain
Harmonious:	Harmonious and Integrated Life, Enlightenment
Disharmonious:	Death, Coma, Complete Unconsciousness

Colors and Consciousness

Most of us are not aware of our daily interactions with colors. Do the main colors of clothing and home environment change during certain phases of life? How does a momentary mood influence the choice of clothes? Anyone who has worked consciously with colors will have realized how simple yet interesting the interaction with colors can be. You can test how you feel, for example, in yellow clothes. Do you feel and think differently in red clothes? You can also experiment with color preference with colors on your friends. When someone wears a cool blue, does that person also have a cool, quiet or introverted personality? In every environment, you will find the colors that correspond to that situation. Why, for example, do most people in discos and nightclubs wear black, violet or dark clothes?

The art of color preference is able to educate us about the subtle areas of our being. It can then help us increase our awareness of our own Self.

The Color Spectrum

As previously explained in the frequency spectrum, ultimately everything is vibration, and each vibration relates to other frequencies. Sound, color, heat, light and magnetism differ from each other only in their vibratory frequencies and the kind of conducting media used. Let us look again at a small section of the frequency spectrum:

Illustration 15

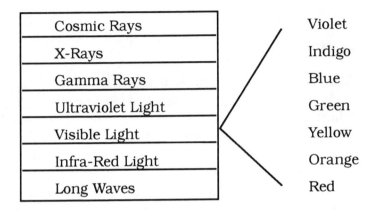

Cosmic Rays	Violet
X-Rays	Indigo
Gamma Rays	Blue
Ultraviolet Light	Green
Visible Light	Yellow
Infra-Red Light	Orange
Long Waves	Red

About in the middle of the known spectrum, a very small bandwidth of waves exists that we can perceive with our human eye. These are the colors red, orange, yellow, green, blue, indigo and violet.

They differ from each other in frequency and wave length. The wave lengths in the range of visible light vary from about 740 nanometers for the color red to about 400 nanometers for violet. The physical eye can only perceive colors that fall in this range. Red has the longest wave length and the lowest vibratory frequency. Violet is characterized by the shortest wave length and the highest frequency of visible light. Beyond the visible light spectrum, we find the infra-red rays on one side of the spectrum, the ultraviolet rays on the other side. Both the visible and the invisible colors can strongly influence our organism and our mood. In color therapy, color frequencies of the visible spectrum are used to change certain physical or emotional states. The art of healing also uses the invisible colors, like infra-red rays, X-rays,

electromagnetic or bioenergetic rays for diagnosis and therapy.

Color Therapy

The famous physician and natural scientist Paracelsus (1493–1541) is regarded as one of the co-founders of holistic natural healing. For Paracelsus, disease was an overall state; it meant disorder in the organism. "Dis-ease" as a state is not—as we often think of it today—an accumulation of many symptoms, which are then listed as various "dis-eases." After all, the balanced, harmonious state of the organism is not called "healths," but "health." According to Paracelsus, there are no diseases, but only sick people. Therefore, no medication for specific diseases (that is: symptoms) are prescribed. Instead, the physician must activate the body's self-healing power. By choosing the correct remedies and treatment methods, at the right time, the entire person (body, mind and soul) will become balanced.

The German poet Johann Wolfgang Von Goethe (1749–1832) studied the effects of color. In his work "The Theory of Color," he recorded his experiences and research studies. Goethe was convinced of the importance of colors and their effect on the human body and psyche. He believed in the close connection between colors and feelings.

Color therapy is often used to activate the self-healing power of the organism. The awareness of the uses of color has increased dramatically over the past few years, both in our private and professional lives. Employers choose certain colors and shades for work

places in order to increase the productivity of the employees and create a pleasant work atmosphere. Many people feel good only in clothes of a certain color. Sensitive people consciously use the colors of their wardrobe. Worn next to the skin, red clothes can have a warming or stimulating effect. Blue clothes can create a certain distance or inaccessibility in interhuman relations. Black or dark clothes are often worn unconsciously by people who have not yet realized themselves, who have problems with their identity and lack self-confidence. Some colors can trigger aggressions or unease.

Illustration 16

When mixing the three primary colors, red, blue and yellow, we receive another color spectrum:

Red and Yellow make Orange,
Yellow and Blue make Green,
Blue and Red make Purple.

When placing all colors in a circle, we can recognize the first laws of colors. The secondary colors orange, green and violet result from the combination of two of the primary colors red, yellow and blue. The complementary color is always located opposite in the color circle. The complementary color of red is green, of yellow violet and of blue orange, and vice versa. The colors red, orange and yellow are considered warm. Blue, indigo and violet are considered cool, and green neutral.

Illustration 17

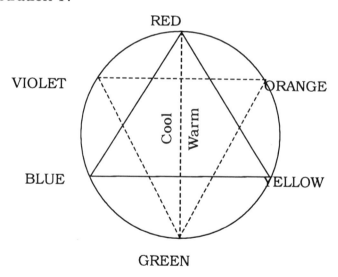

The Meaning of Colors

In color and aura therapies, colors are associated with specific abilities or qualities. Colors can have a healing or stimulating effect on the organism; they can make us sad or euphoric.

The color associations described in this chapter should serve as a general reference only. They are not standardized or static. The color associations are derived from our own experience, from Aura Imaging Photography, color therapy and from particularly sensitive people. Many people have contributed specific qualities and associations which they have discovered in their research work.

The color associations and qualities are very important for the interpretation of an aura picture. The following compilation shall serve as a general overview. It does not claim completeness or medical validity. In case of an illness, a physician or naturopath should be consulted.

First are the warm colors. In color therapy, both the psychological and physiological associations of the individual colors are considered.

THE COLOR RED: The First Chakra

Red stands for the fire element, which is important for all living beings. Without fire, everything would freeze. Without heat, movement and activity would be impossible. Red is used in color therapy when life forces need to be stimulated or renewed, when cut-off life energy needs to flow harmoniously again. Red rays stimulate the liver and form hemoglobin (red blood cells) in the body. They produce heat that vitalizes and energizes the physical body. Red activates blood circulation, the cerebrospinal fluid and the sympathetic nervous system. It helps problems of the sensory nerves — hearing, taste, smell, vision and

touch. In color therapy, red stimulates metabolism and purification. It can dissolve congestion and clots, expand blood vessels and produce blood. When applied excessively, red can cause fever and inflammations. In most cases it is therefore combined with other colors, especially blue. Additional red ray treatment is not done with people who already have too much red, meaning fire and heat, in their body from fever, inflammation, emotional imbalance, hypertension or flushed face.

Organ Association:
Heart, circulation, sexual organs, kidneys, bladder

Temperament: Choleric

Psychological Qualities:
Harmonious: vitality and physical health, will and power, strength, alertness and independence, emotionality (from despair to exuberant joy), motivation, spontaneity, leadership nature, initiative, extroversion, intense and fiery temperament, courage and passion, sexuality and erotic emanation, divine spirit-fire.
Disharmonious: rage, anger, frustration, confusion, violence, destruction, revenge, rebellion, impatience, tyrannical and despotic nature, insanity, over-activity, stress

THE COLOR ORANGE: The Second Chakra

Orange is a combination of red and yellow. Like red, it is a warm color and has therefore a stimulating effect

on the organism. In color therapy, orange is used to treat asthma, bronchitis and other breathing and lung problems. It also supports the calcium metabolism (the spectroscopic color of calcium is orange). Orange has a relaxing and anti spastic effect on the body. It is slightly stimulating and supports the blood circulation. In the psychological area, it is often used when happiness and interest in life are lost and need to be reactivated. Orange combines physical energy and mental qualities. It is associated with the spleen and the pancreas (second and third chakras). Orange strengthens especially the ethereal or biofield body. It has an antidepressant and anti lethargic effect, strengthens the metabolism and promotes health.

Organ Association:
Digestive system, spleen, pancreas, kidneys

Temperament:
Combination of choleric and sanguine

Psychological Qualities:
Harmonious: active intelligence, analytical thinking, self-confidence, inventions, ideas, mental concepts, self-motivation, healing ability, inner and outer communication, prosperity
Disharmonious: ignorance, pomposity, aggression, competitive thinking

THE COLOR YELLOW: The Third Chakra

Yellow activates the motor nerves and thereby generates muscle energy. Since yellow is a combination of red and green rays, it participates in the stimulating energy of red and the regenerating energy of green. Yellow is very advantageous for the nerves and the brain. In color therapy, yellow ray treatment is used for psychological problems like melancholy, depression and weariness of life. It stands for lightness and cheerfulness; it enlivens and comforts. Yellow controls the solar plexus (third chakra) and digestion. Yellow light has a positive effect on the nutritional organs—liver, intestines, stomach, spleen and bladder. Purification and elimination through the liver, colon and skin are promoted by yellow ray treatment and diseases can be prevented. Yellow increases secretion, strengthens nerves and digestion, stimulates gastric juice and lymph flow, and purifies the blood.

Organ Association:
Liver, gallbladder, stomach, intestines, lung, prostate gland, thyroid gland, bronchial tubes

Temperament: Sanguine

Psychological Qualities:
Harmonious: talent for organization, strong intellect and personality, discipline, knowledge, administration, honesty, harmony, good learning ability, career thinking, scientist, business person, politician
Disharmonious: skeptical and critical, stubbornness,

egotist, cynic, control of feelings, ignorance, intolerance, laziness, grief

All warm colors (red, orange, yellow) have activating qualities and are therefore associated more with the yang polarity (yang: male, positive, active, fire, heat). The cool colors (blue, indigo, violet) tend more toward the yin polarity (yin: feminine, negative, passive, water, cold). Green is a neutral color.

THE COLOR GREEN: The Fourth Chakra

Green is the color of nitrogen. With a proportion of seventy-eight percent, nitrogen forms the main component of our atmosphere. It is required for the formation of bones, muscles and other tissues. The color green stands for balance and harmony. Green symbolizes the harmonic cycles of nature and is the main healing color. Green stands for rest, recreation, recovering strength and regeneration. In color therapy, green is used mainly to soothe irritation, to balance disharmonious vibrations and give substance to new life structures. Green is neither acid nor alkaline. It has an effect on the sympathetic nervous system, balances tensions in the blood vessels and decreases blood pressure. Green is considered an emotional stabilizer and stimulant of the pituitary gland. The autonomic nervous system is soothed, and insomnia, uncenteredness and exhaustion are prevented. Green has a balancing, soothing effect and promotes oxygen absorption in the body. It is the color of energy, youth, growth, hope and new life.

Organ Association:
Lung, bronchial tubes, muscles, bones

Temperament: Phlegmatic

Psychological Qualities:
Harmonious: acceptance, hope, expansion, pro-
creation, growth and change, new life, unity of body,
soul and mind, connectedness to nature, communi-
cation, actor, gardener and farmer, universal love
Disharmonious: jealousy, pessimism, resistance, envy,
maudlinity, discontent, superficiality

THE COLOR BLUE: The Fifth Chakra

Although the color blue has the highest energy in
the color spectrum, it has a very calming effect on the
entire organism. Blue is the purest, coolest and
deepest color and stands for rest, recreation, relax-
ation, sleep and regeneration. Blue dissolves nervous-
ness and organic complaints caused by nerves. Blue
decreases blood pressure and heart rate. Blue is the
most important healing color for menopausal com-
plaints. It tightens tissues and hinders tumor growth.
Being cold and electric, it has contracting qualities.
With inflammations, blue can relax and cool. It is also
the color of meditation, spiritual growth, intuition and
higher mental qualities. The throat chakra, seat of the
creative power, is controlled by blue. A too prolonged
blue ray treatment makes some people tired or even
depressed. This can also be observed with blue
clothing or furnishings.

Organ Association:
Sense organs, nerve cells, brain, spinal cord, skin and hair

Temperament: Melancholic

Psychological Qualities:
Harmonious: love, wisdom, truth, trust, politeness, inner balance, rest, centeredness, honesty, silence, security, patience, forgiveness, cooperation, sensitivity, sovereignty, devotion, God consciousness
Disharmonious: reservedness, withdrawal, fear, anxiety, isolation, depression, sadness, passivity, emotional coldness, lack of interest, self-pity

THE COLOR INDIGO: The Sixth Chakra

Because of its cooling, electric attributes, indigo is also counted in the cool colors. Indigo purifies blood circulation. It controls the psychic energy flow of the subtle body through the sixth chakra (spiritual energy center, or third eye). On the physical, astral and spiritual planes, indigo influences vision, hearing and smell.

Organ Association: Ears, eyes, nose

Temperament:
Combination of phlegmatic and melancholic

Psychological Qualities:

Harmonious: inspiration, unity, rest, balance, synthesis, healing abilities, faith healing, inner silence, vision of God, aura vision, priest, psychologist and social worker

Disharmonious: pride, arrogance, restraint, totalitarian attitude toward life

THE COLOR VIOLET: The Seventh Chakra

In color therapy, violet is considered an inspiring and spiritual color. Leonardo da Vinci said: "The power of meditation can be increased ten times through the application of violet light." Violet corresponds to the seventh chakra (pineal body) and has a powerful healing quality. In color therapy, it stimulates the spleen, increases the production of leucocytes and purifies the blood.

Psychological Qualities:

Harmonious: devotion, intuition, creativity, super sensory abilities, ability to absorb spiritual information, idealism, meditative and reflective attitude, transformation and transcendence

Disharmonious: injustice, martyr, obsession, intolerance, impotence, punishment, black magic

THE COLOR WHITE

All colors of the spectrum unite in white light. White sun light contains the entire color spectrum,

from red-orange to blue-violet. In some situations, we can see all these colors, for example in a rainbow, or when light falls through a prism. Many forms of therapy and meditation use white light as a medium for healing or for the transformation of consciousness.

Psychological Qualities:

Harmonious: spirituality, light energy, strong connection to the spiritual, purity and clarity, unity of all colors, higher planes of consciousness, divine energy, enlightenment

Disharmonious: too little contact to earth, daydreaming, too high energy concentration (energy build-up, pain), uncentered, uncontrolled energy accumulation

The Colors of the Aura

Interpretation of colors is never static or absolute. Energy always behaves according to specific patterns, but the cause can be different for each person. For example, a powerful yellow in your aura indicates an active solar plexus center. But there can be many reasons for your active personal energy, ego and intellect. Maybe you are the proprietor of your own company, and you need to emanate self-confidence and power. Or you head a scientific project that requires all your intellectual knowledge. But maybe you try to compensate for your lack of self-confidence with increased personal effort. So we see that a number of factors can cause yellow in the aura. In addition to the knowledge outlined here, keen sensi-

tivity and well-developed intuition are helpful for a more thorough interpretation.

The color definitions are not meant to judge, neither positively nor negatively, and should be understood as neutral energies. Activity, passion and masculinity are neither good nor bad. To be active is basically a good trait. Too much activity, however, can lead to stress and tension. It is the same with idealism. On the one hand, ideals can give us direction and ethics. On the other hand, idealism can turn into fanaticism and rigidity. So in its basic form, energy is always neutral. How people direct and live their energies depends on their consciousness.

Also, every person has a different relationship to colors. Therefore, colors need to be read individually. When asking a group of people to imagine the color blue, everyone will imagine a different shade of blue and associate different experiences with it. For one person, red has a so-called positive, for another a negative meaning. Especially in Aura Imaging Photography, color associations must be seen subjectively. Here is a short list briefly defining the different shades and color variations commonly found in the aura.

Red:	Activity, extroversion, movement, vitality, health, emotionality
Light Red:	Joy, eroticism, sexuality, passion, sensitivity, femininity, love
Dark Red:	Vigor, willpower, masculinity, rage, anger, leadership, courage, longing, malice, wrath
Dark Brown:	Egotism, unlovingness, earthiness, addiction, disease, destruction

Orange: Active intelligence, self-confidence, joy of life, joy of expression, happiness, warmth, sensation, cosmopolitan attitude

Orange-Red: Desire, pleasure, thirst for action, idealism, pride, vanity

Orange-Yellow: Sharp intellect, self-confidence, industriousness

Yellow: Intellect and mind, talent for organization, discipline, personality, ego

Light Yellow: Openness, ease, clear intellect, strong personality, freshness

Ochre: Stability, reality, thrift, tensions, restriction, control, miserliness, egotism

Green: Growth, change, nature, devotion, rest, neutrality, love

Yellow-Green: Sympathy, compassion, communication, peaceableness, frankness

Dark Green : Expression, representation of one self, adaptability, vitality, cunning, cheat(ing) or fraud or deceit, materialisme

Blue: Introversion, rest, deepening, coolness, solitude, truth, devotion, wisdom

Light Blue: Devotion to ideals, softness, religion, solitude, reserve

Indigo: Healing ability, kindness, reticence, seriousness, caution, morality, pursuit of profit, materialism

Lavender: Mysticism, magic, profundity, obsession, intolerance

Pink: Sensitivity, emotionality, femininity, maudlinness, longing, softness

Violet: Intuition, art, creativity, supernatural
 abilities, faith, imagination,
 incorporeality, reticence,
 mysteriousness
White: Developed intellectuality, spirituality,
 vision of God, higher consciousness,
 dreaming, energy build-up, pain

The Form of the Aura

In addition to the color, the form of the aura is very important for the interpretation. It is not enough to consider only the color arrangement. By also studying the form of the energy field, we can understand much about the person. From our experience with many aura photos, we know the form shows a person's basic tendencies. An aura very close to the body can indicate strong reticence or intro-version, usually in conjunction with the color blue in the energy field. An aura extending outward usually indicates powerful energy, activity and extroversion. If high energy concentration is found in or around a specific body part or energy center, this area is more active. For example, when the aura form is concen-trated mainly around the throat center, this chakra receives much more attention. This can manifest itself harmoniously (as in good communication and ex-pression) or disharmoniously (as in speech problems, tensions and inhibitions). It is similar with very little visible energy. Tensions or problems in this area are probably responsible for the decreased energy flow, the aura, however, can change depending on one's general condition. Our experience shows that the main emphases of an aura remains. If one person's crown

center is particularly active, this will show up on all their aura photos in one form or other.

Changes of the Aura

The electromagnetic energy field can change quite fast. The aura color can change from red to red-yellow or from red-white to red-violet within a few minutes. The aura is not static and is subject to change momentarily as well as over a long period of time. How is that possible? Isn't the aura something static that can change only after several months, years or decades?

A person's electromagnetic field is subject to many influences, both from inside and outside. It is possible to see these influences with Kirlian and high-voltage Aura Imaging Photography, which work partially through a technical measuring procedure. Many sensitive clairvoyants report similar patterns, revealing insights into the phenomenon of changes in the pattern of the aura. Factors such as air and food quality, alcohol, environmental conditions, influences of other people and a stressed or harmonious atmosphere can cause the aura to change. When people meet, they exchange some of their energies. A person with a strong aura can unconsciously influence a person with a weak aura, positively or negatively. Strong people can impose their colors on weak people and thereby dominate them. When a strong personality enters a room, this individual is immediately the center of attention, without saying or doing anything. We call this person charismatic, but very few people are aware that charisma really exists as more than an abstract quality.

A group of people with the same interests will often form a kind of group aura. Since all people are in resonance, i.e., they are attuned equally in body, emotions and mind, the electromagnetic energy field vibrates harmoniously and in the same aura color. We can observe this phenomenon at social events.

Of course, one's emotional and mental attitude is very important, revealed in the rays of the aura which are strongly influenced by the thought contents of the mental bodies and the emotional and vital qualities of the physical and ethereal bodies. Kirlian photography is able to show how negative thinking has a blocking effect on the aura and positive thinking a strengthening one. Auravoyant people report again and again that factors like thoughts, feelings, food and environment directly influence the energy emanation around the body. When we talk to someone about a topic that affects us emotionally or mentally, the aura changes accordingly.

Also, the aura can change without us realizing it. According to one's development and momentary condition, every person is at a different stage of learning or state of consciousness. The attention can wander about the different planes of being, consciously or unconsciously, and cause changes in the aura's structure and color. When we dream during sleep, our consciousness dwells in the "astral" or dream world, while we may not know it. Likewise, many people are apathetic and unfocused during the day and hardly notice their environment.

During a conversation, a trained observer can sometimes discover that the subject does not have his attention on the topic, but is dealing with an emotional problem, such as an argument with his mother. In

this case, the conscious mind is not centered in the body, but loses itself in a past feeling. If this inner process is mentioned to the person, they are often not aware of their digression. The same problem occurs in the mental area. If the conscious mind is not anchored in the body, the attention drifts away to some old thought patterns. For example, when talking about money to a person with chronic financial problems, their old thought patterns can become activated immediately: "I don't have enough money, therefore I need to be miserly!" And the person will behave according to this thought pattern.

Most people have difficulty concentrating on one thing, completely uninfluenced by emotional or mental structures, for even a few seconds or minutes. Try it out for yourself. Take a candle and try to concentrate on the flame for one minute, without having a thought or feeling. You will find this is difficult at first.

Integrated personalities who have evolved to a higher plane of consciousness will not let all kinds of circumstances influence them and thereby their auras. Their auras will radiate harmoniously and influence their environment positively. The aura also serves as protection. Only a person with a weak energy field is prone to weakening outer influences. When body, mind and soul are balanced, we are surrounded by a strong, powerful aura. We have the stability to ward off disharmonious influences from our environment.

The problems of environmental and "inner world" pollution are increasing, and our life conditions are changing. Therefore we should have the goal to balance body, mind and soul. This will create a strong electromagnetic energy field. How else can we

understand that many people have a power and charisma that can positively carry us away? Maybe we can now better understand the phenomenon of "holy people." In the presence of a "holy" or "enlightened" person, one feels intense love and peace, without understanding this feeling intellectually. Such a person radiates these qualities even without doing great deeds, solely by their aura, and everyone around them can feel it.

If you are interested in reports of auravoyant or sensitive people, several recommended books are listed in the bibliography. Aura Imaging Photography has been able to confirm these statements through technological, visual means, for the first time. Aura Imaging Photography enables us to display the electromagnetic field of the body. We can compare the statements of auravoyant people to the research on Aura Imaging Photography and thereby gain new insights into our subtle electromagnetic structure.

VII. Aura Photography

Kirlian Photography

Electrophotography or the recording of electrical energy fields on undeveloped film is not new. Long before Semyon D. Kirlian began his work in the 1930s and 1940s in Russia, scientists had already dealt with electrophotography. Michael Faraday, Nikola Tesla and Thomas Edison are only a few of those who came across the mysteries of a subtle energy body and the human aura. Around the turn of the century, Nikola Tesla took pictures not only of finger tip auras, but also of entire body auras.

In the forties, the first experiments regarding an energy body were undertaken. This energy body is a subtle field that surrounds living organisms. Since then many researchers and scientists have dealt with this topic. Probably the best known is the Russian S. D. Kirlian who developed Kirlian photography, a technology with which he was able to record subtle energy fields around living organisms.

Electrophotography usually refers to a phenomenon known as "corona discharge." The corona is the result of electronic discharge, and millions of electrons are displayed. These electrons move from the object to the photographic plate. Depending on the kind of film and electrical generator, beautiful colors and discharge patterns can appear.

In Kirlian photography, the subject puts the hands, usually together with the feet, on a plate which is connected to a high frequency generator. For a short moment, the hand is exposed to high frequency rays, through the plate. The reaction of hand and feet is

recorded on photographic paper. After the development of the film, the Kirlian photo looks like this:

Illustration 18:

Kirlian Photograph of Hand and Foot

Each finger tip has firm contact with the high frequency plate, and each tip displays an emanation. How can this corona discharge be explained? Why does this pattern develop around the fingers?

From acupuncture we know that many energy pathways run through the entire body. We can imagine these meridians as a system still subtler than the nervous system. Certain central points on the skin and the end points of the meridians are known as acupuncture points. These points resonate with the different organs. By stimulating them with an acupuncture needle or by acupressure (gentle pressure massage), the respective organs can be recharged with vital energy, also called "chi." For example, stimulating an acupuncture point of the liver meridian with a needle or by pressure activates the liver as well as other body parts connected to this meridian.

Kirlian photography was able to confirm this knowledge from Chinese medicine. It showed that certain resonance points in the hand, or rather the finger tips, are connected with the respective acupuncture pathways. When we discover irregularities in one area on the Kirlian photo, we can conclude from the resonance points of fingers or hand that energy is congested in the body. In our example: If the area of the liver point shows little or very strong emanation, we can assume that the energy of the liver meridian or other connected body parts is congested.

One of the most interesting phenomena in electrophotography is the "phantom leaf" effect. Several researchers, including Allen Detrick and I. Dumitrescu, discovered an energy field around living organisms. When they cut a leaf in half, they were

surprised to find that they could display around each separated half an emanation in the form of the whole leaf. Even if a physical part of the leaf was no longer present, a subtle energy field continued to exist in the same form as the original leaf.

Illustration 19:

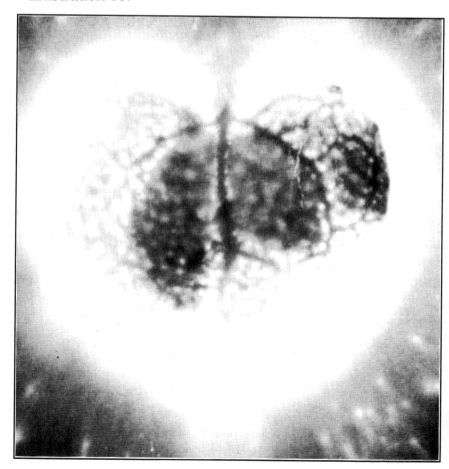

Kirlian Photo of a Leaf

Some theories say that the so-called "phantom limb" pain could be a similar phenomenon. After an amputation, many people still feel pain in that area. Although the physical limb no longer exists, the energy field, determined by Kirlian photography, seems to continue to cause pain.

Illustration 20:

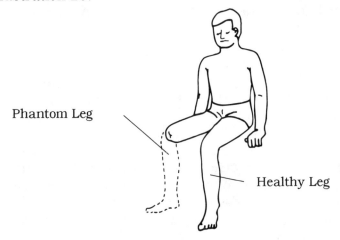

Phantom Leg

Healthy Leg

Although Kirlian photography has been researched and applied for more than fifty years, many secrets have not yet been explained. The functioning of Kirlian photography is as follows:

Kirlian photography visually represents the ethereal and the physioelectrical body of a human being. It shows how the body reacts to electrical stimulation, and it records these changes on film. As in iridology and reflexology, Kirlian photography uses the reflexology points to show organic conditions in the human body. Since a blocked or weakened organ is equivalent to a blocked nerve, only a small or no

electrical change would be displayed in the reflexology points.

So the photographed object and the used frequency of the Kirlian device must resonate with each other. In the phantom leaf effect, the produced frequency and the ethereal energy field resonate. The ethereal structure is associated with a higher vibratory spectrum, a higher octave, than physical matter. Nevertheless, when applied correctly, Kirlian photography is able to display the ethereal energy.

We can understand this process better with the following example. When playing the low C on a piano, this string vibrates in the respective frequency. This vibration causes other strings in other octaves to vibrate. So when we play the low C, the high C will also vibrate, as an overtone. Kirlian photography applies this principle. The electrical energy causes the electrons in the octave of the physical matter to move. At the same time, one octave higher, the resonating tone is stimulated in the ethereal energy field. So Kirlian photography displays the interaction of the ethereal field with the electrical field produced by the Kirlian camera.

Illustration 21:

In recent years, many physicians, naturopaths and therapists have used Kirlian photography for diagnosis and disease prevention by recognizing energy congestions at an early stage. It has been proven that both outer and inner factors (like negative and positive thinking) strongly influence our energy system. For further studies, I recommend the books by Peter Mandel. He developed his own diagnostic system, the energy point diagnosis, a further development of Kirlian photography. Mandel's system has been very successful.

Aura Photography

Electrophotography displays the corona discharge, which is the way the physical and ethereal bodies react to an electrical high voltage potential. A trained user of Kirlian photography can describe from these photos precisely where energy imbalances, and therefore physical problems and diseases, are located.

I would like to summarize briefly the important points about the subtle energy fields: As we saw in the previous chapters, humans are usually not able to transcend the limitations of their five senses. They cannot perceive the subtle energy fields. But there are many people who are able to feel or see the aura. Depending on the abilities of a clairvoyant person, he or she can perceive different areas of the subtle energy field. Without knowing it, many people can partially see the ethereal field. This biofield emanates from the body for about one-half to two inches.

The next step would be to perceive the human electromagnetic energy field. The electromagnetic energy field arises from the flow of energy streams in

the body. When we speak about the aura, we speak
mainly about this part of human existence. Often the
higher dimensional human bodies are also called
"aura." But we differentiate and use the terms "astral/
emotional body," "mental body" and "spiritual body."
The higher energy bodies reflect the emotional, mental
and spiritual aspects of our personality. We can
influence them through continuous, conscious change
of our behavior. Individuals with very unbalanced
emotional lives can mature into emotionally balanced
personalities by increasing their awareness and by
using appropriate therapies or meditation. But this
personality change is a process that requires time.

The electromagnetic field reacts faster to inner
and outer influences and therefore changes more
frequently. The form and color composition of the aura
can vary according to the state of mind or mood. But it
will rarely change extremely within a short time.

Since the electromagnetic energy field is con-
nected to the higher energy bodies, it can indicate the
nature of body, mind and soul. It can inform us about
people's personality structures, their feelings, talents,
desires and energy structures. The physical, mental
and spiritual planes of every person have an individual
vibratory rate. Therefore different colors or color com-
binations of the respective vibratory planes reflect
these three personality planes.

The Development of the Aura Camera

An American research institute developed tests
to measure the electromagnetic field. One wanted to
register the reactions of a subject's palm with an
electrical sensor. A medium or gauge seemed neces-

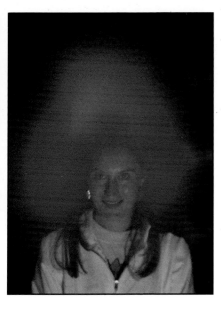

Photo I, 1

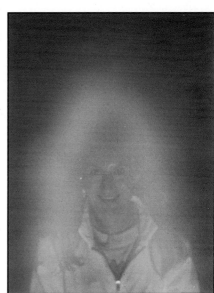

Photo I, 2

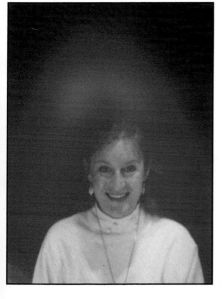

Photo I, 3

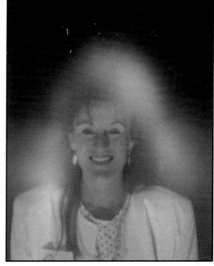

Photo I, 4

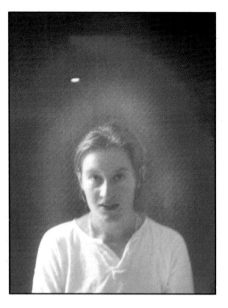

Photo I, 5

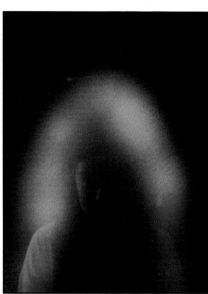

Photo I, 6

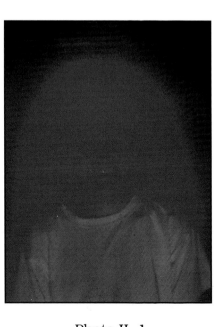

Photo I, 7

Photo II, 1

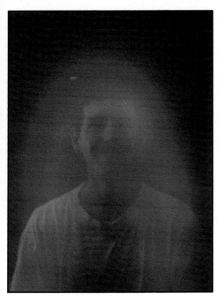

Photo II, 2

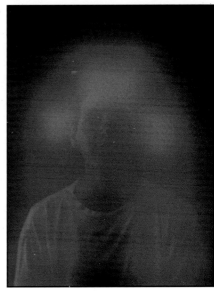

Photo II, 3

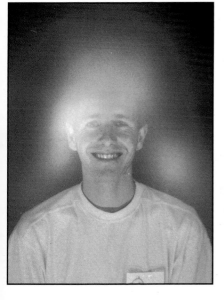

Photo II, 4

Photo II, 5

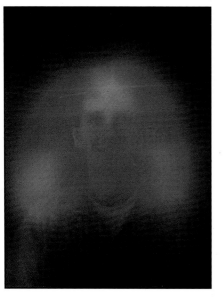

Photo II, 6

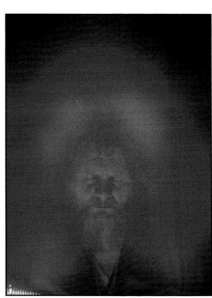

Photo III, 1

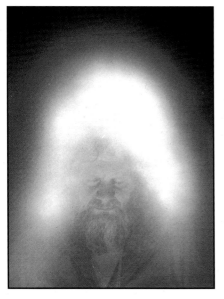

Photo III, 2

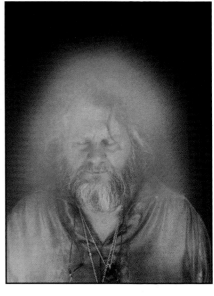

Photo III, 3

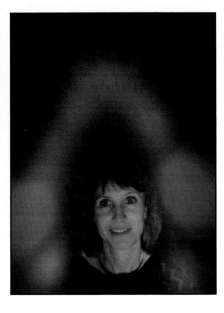

Photo IV, 1

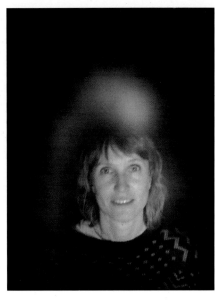

Photo IV, 2

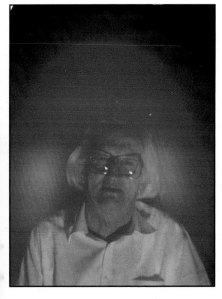

Photo V, 1

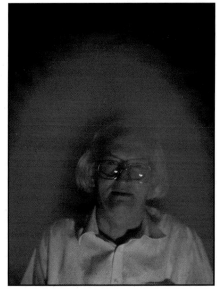

Photo V, 2

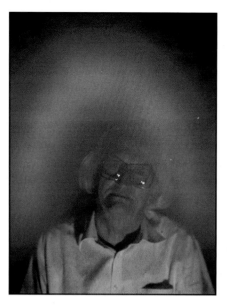

Photo V, 3

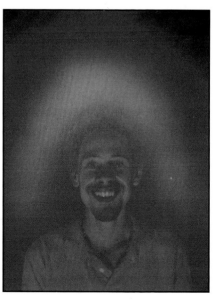

Photo V, 4

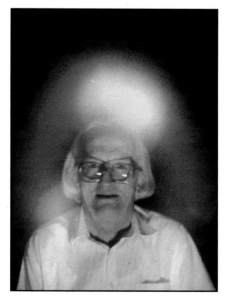

Photo V, 5

Photo VI, 1

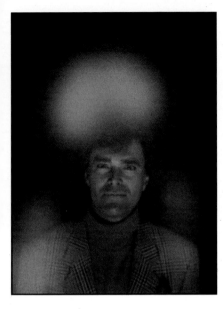

Photo VII, 1

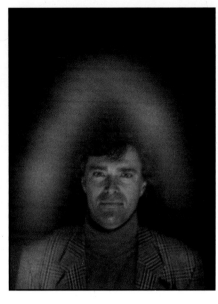

Photo VII, 2

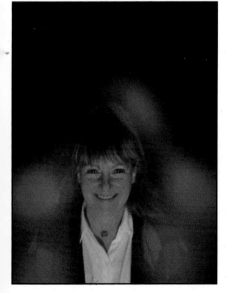

Photo VIII, 1

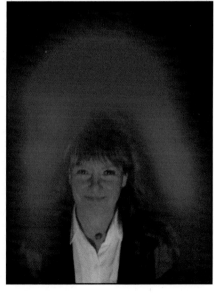

Photo VIII, 2

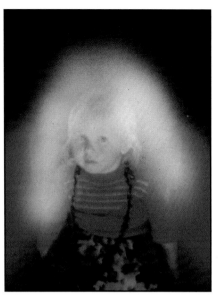

Photo IX, 1

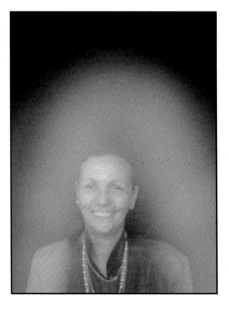

Photo X, 2

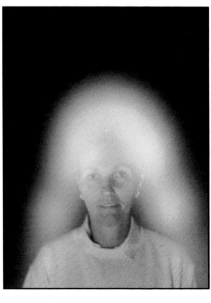

Photo X, 3

sary to measure an energy field that exists momentarily around the body. It seemed obvious to use the hand as the measuring medium. From acupuncture we know that energy pathways, the meridians, run through the entire body. The meridians are connected to all parts of the body, including the different organs. This knowledge is used in reflexology to balance and harmonize specific organs. This is done by pressing and stimulating the reflexology points. The hand, as well as the foot and ear, contain all organs and the entire organism on the level of the subtle energies.

The subjects were led through different emotional and mental states, visualizations and memories, like accidents and childhood experiences. They were asked to attune to these states. During the tests, clairvoyant people who could see a person's aura observed color and form compositions and changes in the aura. A series of experiments established a connection between certain resonance points in the hand, or rather the electromagnetic test results, and the aura. So not only are the organs connected through the reflexology points in the body, but also the human energy field is connected to certain corresponding points in the hand.

Inspired by these test results, the camera Aura Spectrophotometer 2100 was developed. For the first time, it was possible to generate a photographic representation of the aura. This is not a high frequency technology but an optical measuring procedure. The camera Aura Spectrophotometer 2100 is therefore a new concept in aura photography.

Fine sensors scan and measure the electromagnetic energy field of the hand. The measured values represent different vibratory rates and thereby

different colors. The information is then transferred into the camera and translated into the corresponding color vibrations. The resulting color combination corresponds exactly to the unique energy field of a person. The optical system then produces a high quality Polaroid photo which displays the individual color vibrations.

VIII. Aura Photos with Interpretations

This section introduces some tests conducted with Aura Imaging Systems and their results. The different aura pictures of the same subject were taken during different experiments. The explanations describe the experiments in more detail. You can use these descriptions as a reference when interpreting your own aura photo.

We would like to emphasize that for physical or other health problems, you should always consult a competent physician, naturopath or therapist. The outlined principles and the interpretations of aura pictures in this book can in no way replace medical or therapeutic work. They can inform us about our consciousness, our true Self, and about energy processes in our body. As we learn more about our subtle behavioral and personal patterns, we can then work to prevent threats to our well-being. For a detailed analysis and interpretation of your aura photo, consult an experienced Aura Imaging counselor or therapist.

Subject I: M.

Photo I.1: This photo shows a reddish-yellow energy field that centers mainly around M's head. This picture was taken after a seven-hour drive, and it indicates a generally stressed condition, seen mainly in the darker shades of red and yellow. At this time, the attention, or consciousness, is centered in the first and second chakras. M. has been dealing with

physical and emotional realities - the stress of driving. The irregular form of the energy field with many "holes" and "cuts" also indicates the imbalanced condition. In the area of the crown chakra, directly above the head, you can see a dark yellow-brown. Many people experience this color combination as emotional oppressiveness, heaviness, a depressed, discontented feeling or even as headaches and migraine. In this case, due to the long and strenuous drive, M. feels that the energetic streams in her body are imbalanced and result in the head as migraine, and in the shoulder area as tension. The tendency toward tension and shoulder pain can often be found in the aura, and shows when the colors are more faded, or the aura does not continue to flow downward in the direction of the throat and heart areas.

Photo I.2 was taken shortly after photo I.1. Before the exposure, M. used the Wekroma light oil. According to Mr. Werner Kropp, a Swiss scientist, this bio-energetic oil increases physical and mental freshness and activates higher-vibrating "light" energy in the body. A few minutes after rubbing the light oil on the head and throat areas, a strong, brightly shining yellow energy appears on the subject's aura picture. The comparison of photo I.1 with photo I.2 immediately shows a change. Colors and form of the aura are much more vivid and balanced. The primary color in the background of photo I.2 is a strong red (vitality), overshadowed by the strong yellow-gold (light energy). The light oil was also applied to the upper spine, and shows that the energy build-up in the shoulder area has also been balanced. Many experiments conducted with the light oil often resulted in the same phenomenon. After applying the light oil, the aura

changes to a yellow-golden color, indicating that the bio-energetic oil has the ability to noticeably change the energy pathways, and that these changes show in the aura.

Photo I.3: This photo was taken during a very strenuous exhibition. All day long, M. was busy interpreting aura pictures and consulting clients. Interestingly this picture is somewhat similar to photo I.1. At the time the picture was taken, M. felt extremely stressed. As in photo I.1, this condition shows as the yellow-brown hue of the crown chakra. Also, the color distribution and form of the aura are unbalanced. In this picture, the well-developed intuition of the subject shows as red with a beautiful shade of pink-violet. The violet, particularly on the left side of the body in the throat area, indicates a very active throat center and creative, intuitive communication. Powerful violet in the throat area can mean these people are able to express themselves freely and creatively. As in photo I.1, the stress shows in the area of the crown chakra in a dark-yellow hue. In this aura picture, the first and second chakras (physical, emotional) and the seventh chakra (intuition) were again active. Professional consultants and therapists often report they feel fatigued after several hours of work. Many healing successes occur because the therapist listens to the patient's problems and takes on the person's negative energy in the process. Since therapists open themselves up and thereby their energy field, they may report physical discomfort in their own bodies after their sessions with clients.

This also happens to many people in daily life. We talk to someone about trivial things. Suddenly we feel exhausted, or we feel some new sensation in our body.

Photo I.3 shows a similar phenomenon. When we open up psychologically to another person, consciously or, more often, unconsciously, we may absorb this person's disharmonious vibrations. We feel their pain or emotional problems in our own body. Sensitive people are particularly prone to this. Although this phenomenon exists, a healer taking on another person's pain or illness in order to cure them, orthodox science cannot yet explain it.

Photo I.4: This aura photo can be divided into two parts: the upper part shows blue-lavender-white, the lower part a powerful red with an undertone of orange-yellow. The powerful white in the head area indicates that the attention is strongly directed towards the mental-spiritual realm, but it can also mean withdrawal or introversion. On the other hand, the person may simply not want to deal with physical reality, and may wish to escape into fantasy or pleasure. We can observe this phenomenon in many people. At the time the picture was taken, the subject felt inwardly very tense and did not wish to communicate with anyone. In reality though, she had to be very active and extroverted in a busy environment with fast action and many people. The yellowish shade in the throat area represents a blockage or aversion to communication. The red and orange show the outward activity, the extroversion, which is not in harmony with her natural inclination towards reticence and retreat.

Photo I.5: The colors and forms of this aura flow very softly, without any muddy colors or energy blocks. The energy of the aura seems to evenly circulate in the

body without interruption. A blend of red and a strong white produces a harmonious pink-violet. A soft whitish-pink-red ring closely surrounds the entire body, indicating a loving and spiritual nature.. This is often found in people who have been involved in consciousness expanding techniques and regular meditation. This energy picture was taken after a one-hour meditation with Vedic mantras, music and song. The music, visualization and the singing of specific words such as sound OM meditation aimat regenerating the entire organism, balancing the energy centers in the body and aligning the spirit with the divine Self. These picture shows that the person radiates a carefree, positive attitude toward life, is not caught up in materialism, and is involved in creative, artistic or healing activities.

Photo I.6: A law known in metaphysics (meaning, that which goes beyond generally known physics) says: "Energy follows thoughts." Potential energy is always latent, in a state of rest. The idea or thought exists first, before anything physical begins to move or manifest. Human beings are then, what they think. They create their reality through their thinking. Before the picture was taken, M. said: "Okay, I will now visualize blue in my aura." We have to say that this subject has a certain affinity to this color. She can imagine it well and often sees it during meditation. After the visualization, blue is really found on the aura picture! Blue with a soft white shade indicates activity of the higher or more spiritual and creative energy centers, and a consciousness which is directed inward, that is, the aura form is close to the body. Aura Imaging Photography can display technologically what clairvoyant and clairaudiant people have long known.

Visualization, or the power of thought, is not fantasy, but actually influences our consciousness, our subtle body and therefore, our reality.

Photo I.7 was also taken after meditation with mantras. This time, a form of meditation was chosen that activates the sun energy in the body. The energy of the sun, our main energy source, is distributed in our body through the solar plexus center, and can be activated by certain sound patterns and mantras (holy words for the activation of specific energies). This aura picture shows this fact very clearly. The meditation causes powerful yellow-golden color to radiate.

Subject II: J.

Photo II.1: In contrast with the other photos, this aura image shows a light red with a touch of violet centering mainly around the head while continuing to flow lightly downwards. The red radiates outward, like a sun sending its rays. This form often occurs with nervous and restless people. A violet-white energy close around the body indicates that higher vibrating energy is flowing through the body, while not being completely integrated. On this photo, the violet energy field surrounds particularly the crown and forehead chakras, meaning good intuition and a strong tendency to gain knowledge intuitively.

Photo II.2 was taken after a Reiki exercise. Reiki is an ancient self-healing and relaxation technique for the

activation of life energy. This life energy is induced by the laying on of hands and the visualization of symbols. Compared to the previous photo, J's entire energy field is much more harmonious and balanced. The color violet-white has spread from the head area across the entire upper body. This aura form is closer to the body, showing stronger integration and emotional stability. The red-violet against the white background indicates a higher-vibrating, healing and balancing energy flows through the body.

Photo II.3 is somewhat similar to the two preceding photos. But in addition to the red-violet, a yellow hue surrounds the head. On photo I.6, M. demonstrates that our thoughts play a very important role in changing and creating our physical reality. . A blue aura developed after visualizing the color blue. Likewise the plan here is to demonstrate color visualization. J. tried to attune himself mentally to a plant and the color green. When one attunes one's self mentally to something, the attention and energy concentrates on the forehead and the upper half of the head. With eyes closed, visualize, for example, a plant or an object. You can look at this image with the so-called "inner" or "mental" eye. On the aura picture, this shows up in yellow energy around the head, especially at forehead level and above the crown chakra. In this experiment, it was the intellect that was consciously activated and used, a visualization which unites thought and feeling.

Photo II.4: On this picture, as on most of J's aura photos, the strongest energy is concentrated in the head area. When an aura picture shows an overly high concentration of white, the person often has physical

problems in the respective area, or it may indicate congestion of energy . Depending on the position of the color, it may indicate susceptibility to migraines and headaches, tension in throat or shoulders, respiratory and heart problems. Where there is probably some sort of health problem, the color white is usually highly concentrated over the problematic area.

Due to stress and other imbalances, J. has been feeling an intense pressure in the head area, expressing itself sometimes as headaches, often in eyestrain, tension in the forehead or a general feeling of discomfort. These energy build-ups can easily be recognized by their whitish-brown color, particularly in the right forehead and the left shoulder. Since yellow is related to the solar plexus, this color in the crown chakra indicates that the person tries hard to assert his personality and will. Maybe he tries to balance and remedy problematic situations with extra personal effort and energy.

Photo II.5: A morning kiss and hug can light up the aura. The sexual energy or kundalini is a very important energy in our body, and is activated especially when one is in love, close to a partner, or when having sexual or erotic feelings. This energy shows up in the aura as a very light, bright-radiant red. The aura is not close to the body but radiates far outward, indicating attraction, emotional openness, and readiness to connect with the passionate energies, thoughts and feelings of another.

Photo II.6: J. is wearing a head pyramid of different metals — titanium and gold. A beautiful white-violet

shows right on the pyramid tip. The subject had worn the head pyramid for about half an hour. He felt a refreshing and powerful energy in the head area. Through its form, the pyramid is able to center cosmic energies and to pass it on to people or objects. Here the increased vibration (violet-white) is not caused by mental concentration but rather by the application of pyramid energy. When applied consciously, pyramids can activate and harmonize the energy centers in the body and help to expand our consciousness. Through Aura Imaging Photography we have repeatedly recorded many times the positive effect of pyramids on the human body.

Subject III: F.

Photo III.1: F. from Switzerland can visually perceive peoples' energy fields, recognize diseases and heal them with mental healing power. The very powerful violet, in combination with red, indicates his mediumistic abilities and his extremely charismatic personality. The violet is not only around the head, but also in the throat and heart areas. This shows that he can project his creative and healing energies outward. The yellow-orange spots in the brain area may be caused by mental concentration at the time the picture was taken. F. says that he feels intense energy or heat in the body when attuning to the healing energy. We wanted to photograph the changing aura during this process. After F. had attuned himself to the healing energy, photo 2 was taken.

Photo III.2 demonstrates that the subject can attune himself to the divine healing energy within a short time and direct it. The strong white in the head area

clearly shows that a higher vibrating energy is pouring in. This power is also very intense in the forehead area, indicating F.'s powerful healing energy. Interestingly the aura forms on photos III.1 and III.2 are almost identical. Both photos show a powerful energy field radiating outward. Only the emanation near the body has changed in intensity and quality. In photo 2, the attention shifts towards the sixth and seventh chakra in order to let mental energies flow through the body. For most people, such intense energy would be extremely difficult to handle in daily life. Since the energy shifted more in the direction of heaven (the higher energy centers), the earth (the lower energy centers) lack energy. This means less protection against outer influences. Many people involved in activities like meditation and healing are faced with this problem.

Photo III.3: This photo was taken at a later time. F. said that he had just given a very strenuous seminar on faith healing and that he felt completely exhausted. He was not happy with the resulting picture, but it reflects his state precisely. Yellow with a dark hue usually has a limiting effect. The aura close to the body shows that the subject would prefer to withdraw and that he does not want to be disturbed. This is a self protective tendency. He wants to be spared further intrusive and traumatic influences. These three pictures show this very well: When dealing with mental and psychological energies and realities, one also reacts intensely to negative or negative influences.

Subject IV: S.

Photo IV.1: S. Clearly shows the effects of jet lag. The aura picture shows strong imbalances. The tight green-blue ring around the body is disturbed and uneven especially in the head area. The yellow-red in the crown center, the brain, and the shoulder areas indicates stress and tension. Yellow-red in the seventh chakra may represent upsets in the solar plexus and the base center. The subject does not seem "centered" or relaxed.

Photo IV.2: The SE-5 Biofield Analysis Device can measure and balance the finest energy streams in the body (information can be obtained from the author). After briefly using this therapeutic device, S's aura changed visibly. The tight energy ring around the body can still be recognized. The bluish color indicates that the body energies are being balanced, but that this process is not yet completed. It is particularly striking that the crown center still looks uneven. In this area, the energy (white-blue) is more concentrated than in the rest of the aura. Both pictures of this subject have similar energy distributions. The aura is stronger in the upper body and weakens downward progressively. Such a person is mentally free, always active and wants to live creatively and spontaneously. Often, a person with an aura form such as this has an irresistible urge to wander, and seldom remains settled in one place for very long.

Subject V

The scientist Werner Kropp has been involved in bioenergetic research of different disciplines, especially physics and medicine. Friends made him aware of Aura Imaging Photography and we tested the bioenergetic Wekroma* oils in Kropp's laboratory in a series of experiments. Here we evaluate the effects of these products with Aura Imaging Photography.

Photo V.1: This picture shows a red-violet energy field with a light-yellow hue in the forehead area. The light violet indicates strong empathic and intuitive inclinations. Yellow stands for a keen intellect and the ability to put intuitive ideas into action. Often, one of the greatest problems with many outstanding inventors and geniuses is the inability to translate possibly world-shaking ideas into concrete reality. Both the qualities of strong intuition and analytical ability can be seen in this aura picture. Here is a personality able to put forth his unusual, original talents into the world..

Photo V.2: Only a few minutes after taking an ampoule of Nr. 205 (usually prescribed to very ill people), the aura color changed to a powerful darker red with a light orange hue. The form of the energy field is about the same as on photo V.1. Normally this ampoule is used to activate the last survival forces of a person. It is supposed to mobilize the self-healing power and cause the body to regenerate. This aura picture illustrates this. Red is associated with the first chakra, symbolizing the vitality necessary for the continuation of life. The darker hue, color red indicates great physical strength and energy. No higher or spiritual

vibration is emphasized here, but the person's physical force and energy certainly are apparent.

Photo V.3: The powerful yellow energy in this picture indicates an active solar plexus. This chakra regulates our personality, the positive and negative aspects of our ego. When we strive for a great goal with all our effort, the solar plexus is particularly activated. In this aura picture, Mr. Kropp focused on his personal goals and scientific projects, the result being a strong yellow in the auric field. Interestingly, we had been able to achieve similar results when the person being photographed was asked to concentrate on goals and intellectual pursuits.

Photo V.4 shows the subject after a short laser acupuncture. A specifically developed, very powerful laser, reinforced with vector fields, was beamed on the left earlobe for a few minutes. The very intense white clearly shows an increased energy flow. The strong white is not surprising since laser, in connection with vector fields, represents an energy source fed by a higher vibratory plane. This photo shows brighter hues than all previous photos of the subject.

Photo V.5: From the many pictures we took after applying bioenergetic products and technologies, the following photo is an interesting aura picture. Photo V.5 of Mr. Kropp again has a powerful red in the background. The throat and heart areas show a light blue-white color, the crown center a powerful white sphere. The sphere indicates a more active crown center, an opening to higher, more spiritual energies and levels of consciousness. This aura picture was

taken after the subject consciously attuned himself to the archangel Gabriel. The left hand was resting on an antique picture of the archangel. This photo shows that the subject is a very powerful medium. Since he focused on the archangel Gabriel for only a few minutes, the entire body was not enveloped in white light. For a deeper contact, more rest and withdrawal is usually necessary.

Subject VI: A.

Photo VI.1: This aura radiates widely outward. Together with the color combination yellow-orange-red, it means that A. is a very open-hearted, sociable and extroverted individual. The light yellow or orange around the body indicates a happy, uncomplicated personality. The violet-white hue in the head area stands for strong creativity and empathy. This person bubbles with vitality, but sometimes has problems centering his energies and directing them properly.

Subject VII

Here again, is another application of bioenergetic products is recorded on aura photos. Aventurin was formulated by Mrs. Dobler, who works as a bioplama researcher in her husband's dermatology office. In her thirty years of research, she has developed many bioenergetic products.

Photo VII.1: A soft green surrounds the subject's body, and the green is reinforced by yellow, mainly in

the crown center. There is also a gap, but here it is filled with a light red, and indicates intellectual strength, and a rational thinker. Red combined with the color green indicates a good connection to the earth and material reality. The yellow-green in the crown center indicates a conscious involvement in the outer world. This pattern also shows the person is experiencing big changes in their life. The person's centered aura form, distributed evenly around the body, signifies his relaxed, quiet effect on other people.

Photo VII.2 differs only slightly from the previous aura picture. The form is more evenly balanced, the gaps in the brain area have disappeared and the energy accumulation in the crown center is somewhat loosened. This photo was taken only a few minutes after applying the Aventurin drops and cosmetics. One can generally say that changes in the aura do seem to show up after a short time. Sensitive people report witnessing these changes in the energy flow again and again. These so called subjective observations are real, existing phenomena beginning to be scientifically proven, which we hope will be researched on a larger scale in coming years.

Subject VIII

Photo VIII.1 shows a subject with a reddish energy field very close to the body. Above the head is a pale white-blue, in the forehead area a yellow-orange. Yellow in the intellectual center means most of the person's attention is focused there. Information is absorbed mentally. On the other hand, the crown center is very active and attempts to process

experiences consciously, and rationally. The aura form is not particularly balanced; this person seems to be involved in many diverse activities.

Photo VIII.2: Shortly after applying the creams of the Aventurin cosmetics, the subject's physical energies are being balanced and smoothed out. The red is much clearer and lighter, and the form of the energy field is more even than on photo 1. Since the energy field fades downwards, the harmonizing has not yet been completed. The attention, the most intense accumulation of energy, is in the head area.

A common misunderstanding about harmonizing the electromagnetic field does not mean that a disease or a physical, emotional or mental problem disappears immediately. Rather, the more we approach the cause of the problem, the faster and easier the problem can be handled. Which path should be taken can be disputed, but energy medicine (cures and therapy forms that integrate body, mind and soul through subtle or energetic techniques) has been able to prove in the last decades that even serious health and emotional problems can be treated and improved through continuous, long-term treatment of the subtle energy systems.

Subject IX: M.

Photo IX.1: In my view this is one of the most beautiful pictures of our photo documentation. Children can of course also be photographed with Aura Imaging Systems. Most children still radiate an innocence and purity lost in many adults. Children experience their environment with different eyes; they often see things

that adults can no longer see. Therefore adults often have difficulties understanding the world of their children.

This aura picture divides into two areas: the beautiful bluish-white corresponding to "heaven" and the powerful red associated with "earth." One could say that this child lives in a physical body, but spiritually belongs to a different world.

Subject X: R.

Photo X.1 shows the subject after taking different Bach Flower Remedies. The upper head area has a powerful yellow-orange color, the lower head and shoulder area a paler blue-white. The activity of the body has shifted upward. The yellow-orange in the sixth and seventh chakras shows the person is becoming aware of psychological and intellectual circumstances. The yellow in the crown center indicates that the person is very self evolved.

Photo X.2: Green is the color of communication, self-expression and openness. This aura picture was taken during a seminar. She was ready to be involved, either in communication or in activity. A green aura emanating evenly around the body signifies a good connection of body, mind and soul. She is firmly grounded on earth and opens her heart to other people. At the same time she is receptive to mental stimulation. The soft yet powerful green is completed by a turquoise-blue color close to the body indicating a pervasive healing energy . A green-blue aura picture indicates the heart and throat chakras are open and there is a willingness

to love, communicate, patience to listen to, and connect with others.

subject XI

Photo XI.1: Here is a picture of a holistic healing session at an exhibition. The client lying down for treatment had his aura photos taken both before and after the appointment and are shown in photos 2 and 3:

Photo XI.2: This is the aura photo taken before the healing session shown in photo 1. The dark, almost indigo blue suggests fatigue and perhaps exhaustion. Since the color is rather dull and even all the way around this man's head, he is probably experiencing an emotional funk. The splash of dark red indicates he has recently been tremendously upset. Often, a large amount of dark blue in the aura mixed with spots of dark red mean the person is emotionally drained and physically weak from feeling angry and frustrated.

Photo X.3: Try to interpret this one yourself. The color interpretations given in this book will be helpful, but you should try to examine the aura picture for some time using your own feelings and intuition. Why does the energy form lie close to the body? What do the colors white and blue mean? Why is the aura centered mainly in the upper head area? Now you really should stop reading and examine the picture!

Photo Xl.3: This spectacular experimental photo is a beautiful example of how aura imaging systems can record changes in a person's energy field. Look how

Holistic healing

The Biofeedback Camera 3000 can be used to demonstrate the effects of a particular therapy technique. For best results take the subjects photo as soon as they come into the office, and again after the session. Keep the environment quiet and the temperature a constant 22 degrees C which is 72 degrees F. Look for slight changes in color. A change in hue with the colors shifting toward the violet is normal for a successful therapeutic session.

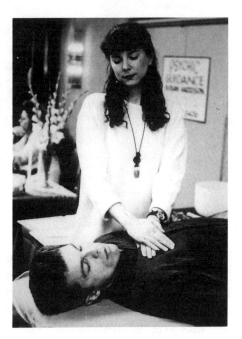

before

after

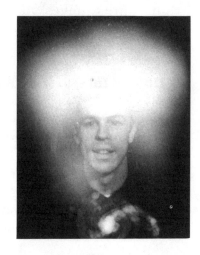

the subject's aura now radiates after his holistic healing session! What an energy shift! Notice how the heart chakra has opened up and is radiating! You can actually see the energy spinning! This lovely photo has actually recorded how the energy has changed and shifted, and has also validated the effectiveness of the healer's ability and technique.

subjects XII and XIII:

Photos 1 and 2: Aura Imaging can also reveal compatibility between people who are emotionally close. The couple in these photos are obviously matching energy. Notice how they have the same colors in more or less the same locations. The bright hues even match! Photos with similar, or even identical looking auras often appear in couples who get along especially well, in friends with much in common, and sometimes in entire families! Also, people experiencing the same problems and challenges together will often have similar looking energy fields.

How to Interpret an Aura Photo

An aura photo can be divided into three different parts in order to be easily read: the right side of the photo, the left side, and the space directly above the head. The right side represents the masculine principle, outward, or yang energy, what the person is expressing, or the personality one presents to others in everyday life. Also, the right side portrays the recent past.

The left side, on the other hand, symbolizes the feminine principle, yin energy, what the person is attracting, or what is coming into one's life. The left side also represents the near future, from as soon as a few hours to several months ahead.

The colors in the space above the head define the state that person is in at the present time. If there is a different colored band at the very top of the aura, this color may symbolize the aspirations, goals or deepest wishes of that person.

For example, if there is a big red area on the right side of a person's aura photo, this most likely means the person is expressing abundant vitality, is extremely active and outwardly emotional in their daily life, and probably has experienced a very busy, challenging week. With a dark blue spot right above the head, in all likelihood you might say that person is presently taking some time-out to relax, or if the area is very dark and dense looking it probably means he is very tired, sad, or perhaps depressed. With green on the left, you might interpret that the person would like to incorporate some peace and healing time into their life in the near future, a vacation, or a relaxing change in their hectic schedule might be likely.

Bright, vivid, radiating colors generally show health, well being and happiness. Faded, washed out colors indicate sensitivity and a more introverted nature. Muddy and dark colors usually reveal sadness, emotional frustration or health problems.

The shape of the aura can be interpreted too. If an aura looks bright and extends widely around the person's head, the person is probably feeling happy, optimistic and good about himself and life in general.

An aura which looks small and does not radiate far from around the head may mean the person is unhappy, afraid, listless, ill or uncommunicative. If the shape of the aura looks even on all sides, this indicates a well balanced, or consistent personality. Gaps or dark holes in the aura usually symbolize a loss or a will to let go of something or someone significant in that person's life.

Uneven streaks jutting out from the head show nervousness. Sometimes a line appears from the top of the photo right down to the center of a person's head and usually indicates psychic ability. Occasionally bubbles, orbs, stars, faces and many other interesting symbols mysteriously appear, and who knows where they came from!

All you really need to know in order to interpret successfully is to first understand what all the different colors and shades mean, then look at which position that color appears, and remember what that position signifies, then note the general shape. Remember, the warmer colors, red, yellow and orange generally show extroversion, expressiveness, practicality and vitality, while the cooler colors, blue and green show more sensitivity, peacefulness, and a more inward and intuitive nature. Violet and white indicate vivid imagination, magic, and a spiritual orientation towards life.

Bibliography

Hands of Light by Barbara Ann Brennan, c. 1987.
　　Bantam Books
Stalking the wild pendulum by Itzhak Bentov, Destiny
　　books Rochester, VT
Healing through Colour by Theo Gimbel, Edition C.W.
　　Daniel Saffron Walden, UK
Let there be light by Darius Dinshah, Dinshah Health
　　Society, Malaga, NJ
Death of Ignorance by Dr. Fred Bell, Pyradyne Laguna
　　Beach, CA
Vibrational Medicine by Richard Gerber, Bear & Co.
Colour your life by Howard and Dorothy Sun, Piatkus
　　Publisher, London

Dear Reader,

If you are interested in the latest developments in Aura Imaging Photography, the aura cameras or the aura video, if you want to attend lectures or seminars or if you want to have your own aura picture taken, please contact:

Johannes R. Fisslinger
520 Washington Blvd. # 907
Marina del Rey, CA 90292
Phone 310-301-1006 • Fax 310-578-2060
E-mail johannes@inneractive.com

Winfalcon's
Healing Centre

28/29 Ship Street, Brighton, Sussex BN1 1AD
Tél: (01273) 728997 Fax: (01273) 720411

"Aura" Camera

We use the camera as a basis for counselling, to monitor progress when having treatment, to show how healing, crystals and remedies affect the energy field, to assist with diagnosis. We offer a 10-minutes analysis of the photo (on tape if required) or a half-hour consultation with photo.

We also use the camera as a recruitment and management consultancy tool to ensure that the candidate is well suited to the vacancy or to advice on career decisions. It can also monitor the effects of training courses.

We supply cameras and our own camera is also available for hire.

Our Healing Centre offers a great range of therapies from aromatherapy to Yoga with free mini-consultations to enable the correct therapy to be chosen. We hold regular meditations, lectures and workshops.

Our shop has purple energy plates, mind machines, a large range of crystals, remedies Tarots, incense, oils, books, tapes, mystical cards, posters, figures and much more. Most items are available by mail order. Readings using Tarot, I Ching, astrology, etc. are available.

For more information phone or send a large stamped addressed envelop or IRC if outside UK.

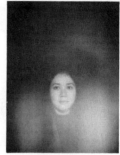 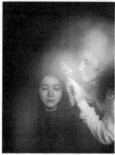 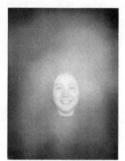